IMAGES
of America

THE BRIGHTON AREA

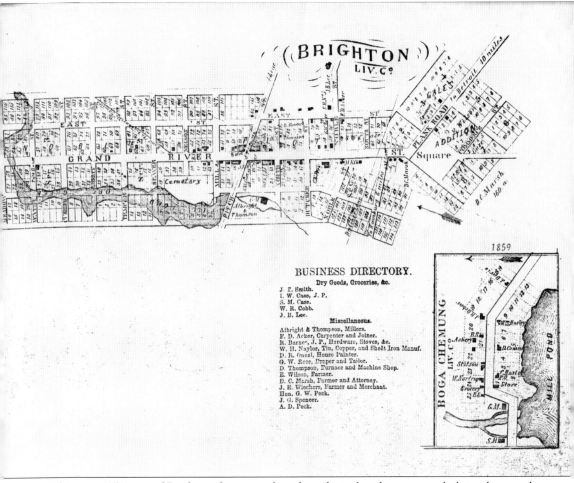

BUSINESS DIRECTORY.

Dry Goods, Groceries, &c.

J. P. Smith.
I. W. Case, J. P.
S. M. Case.
W. R. Cobb.
J. B. Lee.

Miscellaneous.

Albright & Thompson, Millers.
F. D. Acker, Carpenter and Joiner.
R. Barner, J. P., Hardware, Stoves, &c.
W. H. Naylor, Tin, Copper, and Sheet Iron Manuf.
D. R. Oneal, House Painter.
G. W. Rose, Draper and Tailor.
D. Thompson, Furnace and Machine Shop.
E. Wilson, Farmer.
D. C. Marsh, Farmer and Attorney.
J. E. Wiechers, Farmer and Merchant.
Hon. G. W. Peck.
J. G. Spencer.
A. D. Peck.

This rare 1859 map of Brighton shows numbered residential and commercial plots, along with a business directory. (Courtesy of the Brighton Area Historical Society.)

ON THE COVER: Brighton residents are marching east on Main Street towards Grand River Avenue in the 1907 Homecoming Parade. The E.G. McPherson building is the two-story structure to the right of center, with three windows on the second floor. Boys follow alongside the Brighton Community Band.

IMAGES
of America

THE BRIGHTON AREA

Genal Pratt with the
Brighton Area Historical Society

ARCADIA
PUBLISHING

Published by Arcadia Publishing
Charleston, South Carolina

Printed in the United States of America

Library of Congress Control Number: 2012935819

For all general information, please contact Arcadia Publishing:
Telephone 843-853-2070
Fax 843-853-0044
E-mail sales@arcadiapublishing.com
For customer service and orders:
Toll-Free 1-888-313-2665

Visit us on the Internet at www.arcadiapublishing.com

To Leland and Nolan, with all my love

CONTENTS

ACKNOWLEDGMENTS

This book would not have been possible without all of the countless hours of generous help, extensive historical knowledge, and dedication of Jim Vichich. I am in your debt. I would like to thank Marieanna Bair and Larry Lawrence for their invaluable help and input. I would like to acknowledge Carol McMacken's book *From Settlement to City: Brighton, Michigan, 1832–1945*. Her dedicated research of Brighton's history was imperative to writing this book. I would also like to thank Dave Ball for his contributions. Many thanks go to my husband, Lee, and my son, Nolan, for their love, support, and patience. Unless otherwise noted, all images are courtesy of the Brighton Area Historical Society.

INTRODUCTION

Brighton originally had no separate organization of its own. Instead, it helped compose an important part of the township of Green Oak. Then, in April 1838, it became its own distinct district, eventually forming the village of Brighton in 1867. Maynard Maltby of New York arrived in Brighton with his younger brother Almon. He purchased the very first piece of land in the township of Brighton on August 28, 1832; he also owned and operated the first sawmill in the area. In March 1833, Horace H. Comstock purchased land north of Fitch Street and east of the Millpond. Anthony Gale bought land south of Fitch Street and east of Ore Creek in September 1834. In 1835, Elizabeth Cushing purchased the portion of land north of Main Street and west of the Millpond. Elijah Fitch owned the land south of Main Street and west of Ore Creek.

Elizabeth Cushing and her husband, John Cushing, moved to the land she had located, becoming the very first settlers in what would later become the village of Brighton. That same year, their son Benjamin Cushing built and operated the first log tavern. Other settlers followed in rapid succession, and by 1836, there was a cluster of log houses within the limits of the village. For a few years, people called it Ore Creek, after the stream running through the area.

In 1837, the first plat of the village was made by William Noble Jr. and was called the Village of Brighton. From then on, the name Ore Creek was dropped. Noble's plat of land was referred to as "lower town," and Gale's plat was referred to as "upper town." The first frame house in Brighton, built on Lot 51, Section 2, was owned by Maynard Maltby. Later, the first tinner in town, Malcom Fitch, bought the Maltby house. He ran his business out of a two-story building on Grand River Avenue. Truman B. Worden built the second frame house. He died in 1837 and was the first person to be buried in the Brighton Village Cemetery. The first schoolhouse was constructed of logs in 1837 on Grand River Avenue.

The first child born in the village of Brighton was Louis VanBuren Curry, on October 25, 1837. He served as a lieutenant of the 9th Michigan Infantry during the Civil War. Curry later moved to Fenton, where he served as postmaster for many years. The first physician in town was Dr. Wilbur F. Fisher in 1836. Maynard Maltby became the first justice of the peace for the township in 1838, and he performed the first marriage ceremony in the village for William Winchell and his bride.

William Noble Jr. kept the first store in the village. The first blacksmith was Abram Fralick, who came from Plymouth, Michigan, in 1838. In 1839, the first local attorney was Daniel C. Marsh, who was the first prosecuting attorney of Livingston County, appointed by Governor Woodbridge in 1841. Nicholas Sullivan established the first printing office in 1843. The weekly paper was called the *Livingston Courier* when it was located in Howell. A year later, when it was moved to the village, it was renamed the *Livingston Democrat*. C.E. Placeway was only 19 years old when he started and ran the *Brighton Argus* in 1879. David Thompson built and operated the first and only foundry in the village in 1843. Early merchants of Brighton include William Noble Jr., Robert Thompson, D.S. Lee, William McCauley, Orson Quackenbush, John G. Spencer, Denton Sayers, W.R. Cobb, L.B. Lee, Spalding M. and Ira W. Case, Charles Gregory, Truman D. Fish, and Aaron H. Kelly.

In 1850, the second schoolhouse was built just south of Corydon Pratt's residence. Then, in 1868, the Union School on Rickett Road was constructed, and it served as the high school for Brighton for 60 years. Carl Conrad built Brighton's first electric plant in 1897. He installed wiring in local homes virtually free of charge to encourage the use of electricity.

In 1870, the Detroit, Howell & Lansing Railroad Company was formed, and by that September, it consolidated with another company to form the Detroit, Lansing, Lake Michigan Railroad Company. Soon after, this became the Detroit, Lansing & Northern. On July 4, 1871, Brighton residents by the hundreds were waiting at the railroad crossing on West Main Street. They were there to celebrate the opening of the railroad. They were impatient, as they had been waiting a long time. With workers moving from both Detroit and Lansing, the tracks met in Fowlerville in August 1871. It was renamed the Pere Marquette Railroad (later Railway) by 1915.

Although Brighton is the compilation of many people and their contributions to its growth, there are some early characters who embody what Brighton was, and what it was to become. A permanent resident in 1832, Benjamin Blaine was a hunter and trapper who lived off the land. His connection to nature led him to discover that the stream running through the village was fed by iron-rich springs, and he aptly called it Ore Creek. Adopted before Brighton became the permanent name in the late 1830s, Ore Creek is associated with Blaine.

B.T.O. Clark also left his mark on Brighton. Born in 1836, he arrived with his parents from New York in 1837. Clark resided in Brighton his entire life. As many people came and went through the years, Clark remained rooted to the town of Brighton, becoming the citizen who lived in Brighton the longest.

The beauty of Brighton can be attributed to the large amount of sparkling lakes and rural landscape in general. The old town has changed with the times, but a few things remain the same: the beauty of the land, the charm of the downtown, and the sense of community amongst its residents, which truly make it the "Arcadia of Michigan."

One

MAIN STREET

As early as the late 1800s, Brighton's Main Street was already bustling and full of promise. The steady transition from horse and carriage to the automobile was reflected in its businesses and lifestyle. Blacksmiths gave way to gas pumps, and muddy dirt roads to smooth concrete streets. The roads and walkways of downtown Brighton were illuminated in 1897 by arched strings of electric lights. Constructed by C.C. Conrad, the first electric plant provided service in Brighton from sundown to midnight, enabling businesses to stay open a bit longer.

Laid by 1871, the railroad modernized Brighton's downtown. Trains brought family and friends closer together and allowed residents to work farther away from home than ever. At the convenient Western House Hotel, traveling salesmen stayed for a time while they sold supplies to Main Street merchants. The growth of the town offered residents new products and services, including modern equipment that would make the jobs and lives of local farmers far easier.

As with most downtowns, Brighton's Main Street was the focal point of the city. On Main Street, merchants sold their goods, families enjoyed leisurely strolls, and acquaintances grew into good friends. Alive with the sights and sounds of midwestern America, Brighton's Main Street was bursting with charm and change. It is still considered the heart of the city today.

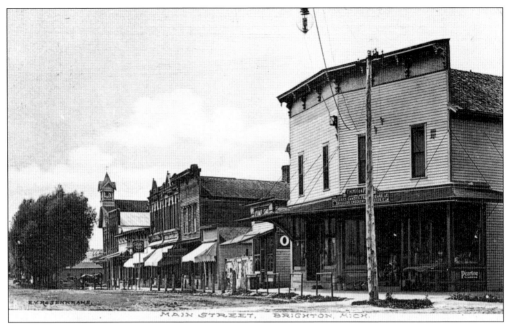

Seen in this c. 1906 photograph, the Fred Miller Grocery located on the north corner at 100 West Main Street sold candy, dry goods, and cigars. It also housed the town's first public telephone; phone calls could only be made during store hours at that time. Hitching posts drew a barrier between the sidewalks and the roads. A fire claimed the top floor of the store, and it remains a one-story building today. Lu and Carl's restaurant now occupies the space.

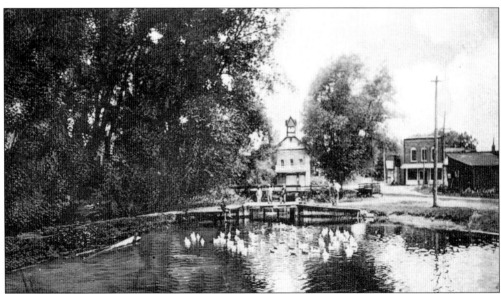

Seen here around 1906, the Millpond remains an icon of Brighton. Originally located on both sides of Main Street, the Millpond was a good place to leisurely fish and feed the ducks in the searing summer months. This photograph was taken from the former Brighton Mills building. The dam was relocated after it broke in the 1950s, causing the Millpond to remain only on the north side of Main Street.

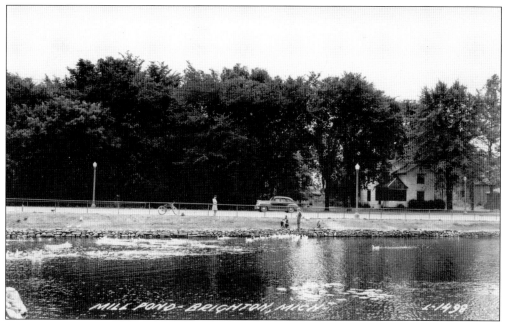

This 1940s photograph shows the Millpond to the south. The W. Cook family house, later relocated to North First Street, is to the right. Today, the Wirth family resides there. Huge trees line the space where Ciao Amici's restaurant is now located at 217 West Main Street. The Millpond stretched to the south side of Main Street behind the trees and the old dam was located on the left in this photograph. The metal fence has long since been removed.

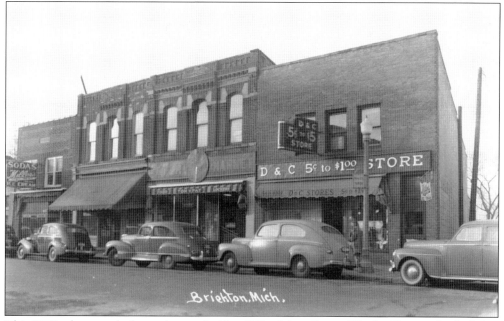

This 1940s photograph shows the north side of West Main Street. The building to the far left is Paul Deluca's Sweetshop. In the center, Tom & Pat's Market store rented out freezer locker space. The Line family owned the D&C Dime Store. Oddly, the sign on the building says 5¢ to $1, but the sign above says 5¢ to $5.

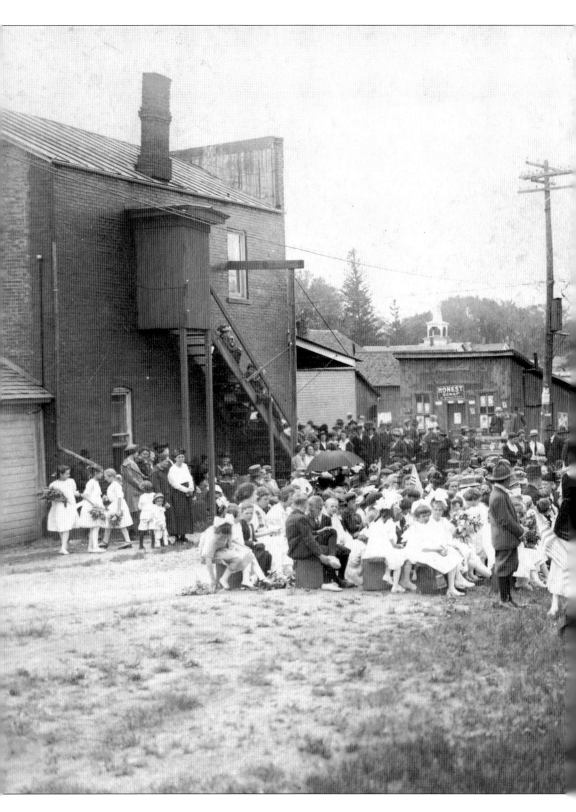

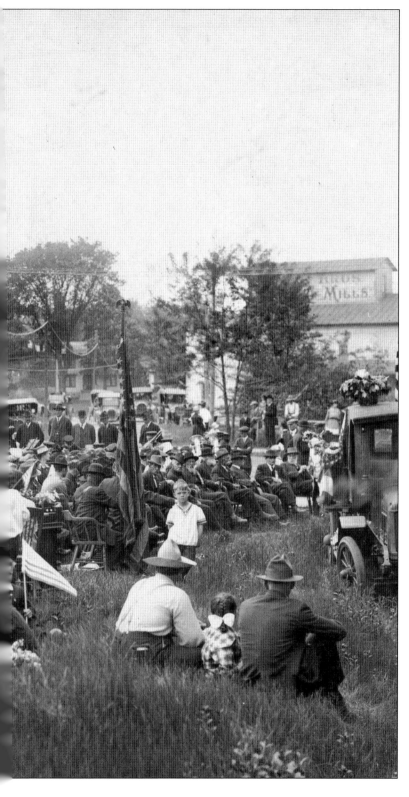

A 1920 Memorial Day parade is held in honor of veterans. The entire community gathered together, lining the streets to pay their respects to the soldiers who fought for the preservation of freedom. Veterans are speaking in front of the town hall to the right. James Collett, who came to the area in 1875 to practice the joiner and carpenter trade, built town hall in 1879. With a flat roof, it was constructed at 202 West Main for $2,300. Collett also built St. Paul's Episcopal Church, located behind town hall, in 1881. Town hall was built to house the fire department on the first floor, with a large-sized door on the left to accommodate the fire truck. City hall operated on the second floor. Brighton Mills and the Honest Scrap building are in the background across Main Street.

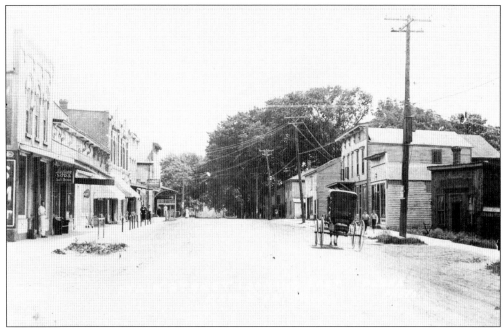

In this view facing east from Main Street, Grand River Avenue is visible around 1910. The building on the left remained a bank for many years before it became the Yum Yum Tree in 1980. The third storefront on the left is the post office. To the right, the small black building is the Honest Scrap building. Two storefronts past Honest Scrap, a millinery shop carried fashionable ladies' hats.

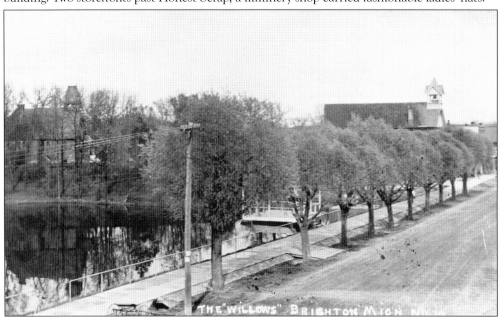

Billowing willows once lined the north side of Main Street around 1910, providing shade and beauty. The sidewalks were a welcome addition. Not only did they prevent the ladies' long dresses from being ruined, they also gave a place for the kids to play catch instead of on the streets. Farmers complained the boys' games were scaring their horses. The white structure on the Millpond just behind the willows is the bandstand.

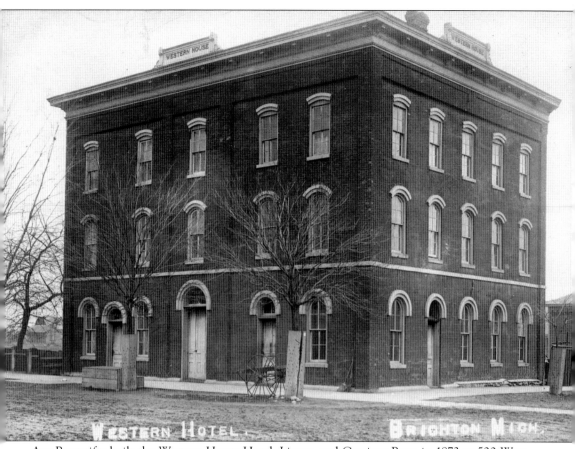

Asa Rounsifer built the Western House Hotel, Livery, and Carriage Barn in 1873 at 500 West Main Street. Pictured here around 1910, the hotel was constructed in anticipation of the influx of travelers due to the railroad newly constructed in 1871. Traveling salesmen came by train and tried their luck at selling their goods to downtown merchants. In 1926, Edward E. Standlick became the owner of the hotel, which he planned to use for residential purposes.

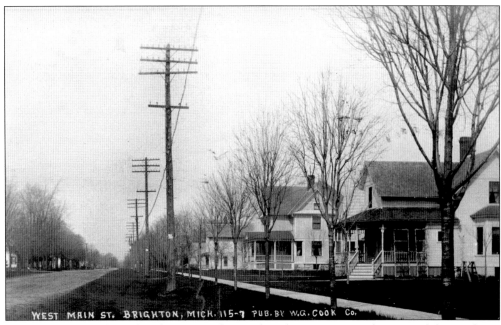

WEST MAIN ST. BRIGHTON, MICH. 115-7 PUB. BY W.G. COOK Co,

Vice president of the railroad E.G. McPherson bought property to the west of the tracks in anticipation of the growing population. McPherson helped determine the railroad's path through Brighton. Note the sidewalks and trees that provided suburban appeal. The look of midwestern America was beginning to take shape.

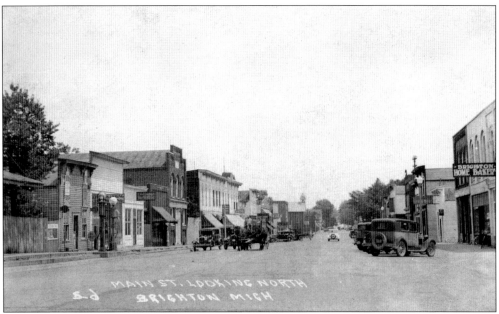

MAIN ST. LOOKING NORTH
S.J. BRIGHTON MICH

The mix of cars with horse-drawn carriages on the road is a mark of the changing times in the 1920s. Blacksmiths were all but disappearing. New gas pumps were popping up along Main Street, making hitching posts obsolete. The automobile represented irreversible change, while the pounding of horse hooves could still be heard. When Lansing became the capital in 1850, Brighton had become an ideal and popular spot to stop when traveling between Detroit and Lansing.

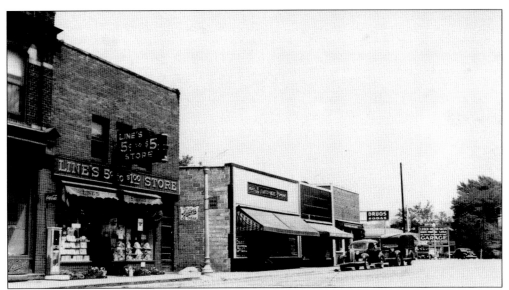

In the 1930s, Line's "5¢ to $1" store had a penny scale in front, where a person could weigh himself or herself for a penny. Summer annuals lined the sidewalk out front. The white building next door is the Great Atlantic & Pacific Tea Company (A&P). Leland's Drugstore now stands on the corner that Fred Miller's once occupied. The Line family, well known throughout Livingston County, also owned a store in Howell.

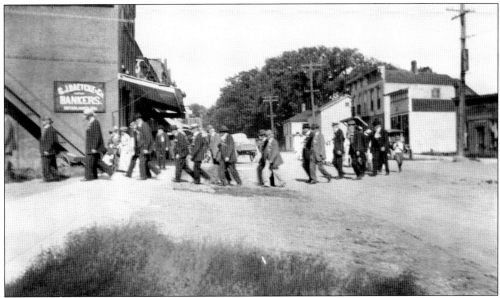

On a Memorial Day in the early 1900s, Civil War veterans of the Grand Army of the Republic march past G.J. Baetcke & Co. Bankers at 140 West Main Street. They are on their way to the Village Cemetery. In the 1880s, former slave John McKinney lived on the second floor and worked as the bank's night watchman. Although he was a trusted and well-liked man in the community, many citizens did not want him buried in the Village Cemetery. McKinney was buried on property that was owned by St. Paul's Episcopal Church and next to the cemetery. Today, the Yum Yum Tree restaurant occupies the former bank space, and the marks from the old bank vault are still visible on the floor.

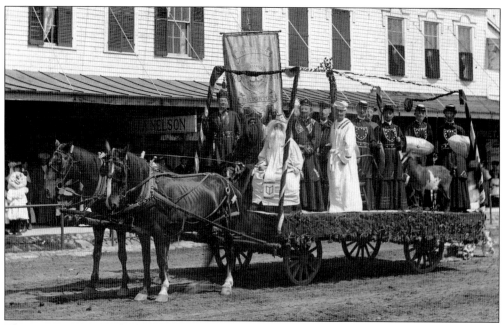

The Main Street parade float passes in front of the J.A. Nelson building on Main Street around 1909. J.A. Nelson's was located between what are now Brighton Bar and Grill at 400 West Main Street and Great Harvest Bread Company at 416 West Main Street. The riders of the float are wearing masks, and their banner reads, "Sinai Tent, Brighton Michigan, KOM #44." The Knights of the Maccabees met on the second floor of the building site now occupied by Stone Fire Bistro.

This photograph shows east Main Street around 1910. Hyne Street is to the right of the walkway. The willows in front of the Millpond are visible in the background. The building on the right is Ratz's Hardware. Two storefronts down is the former Weber Bros. blacksmith shop, with its identifiable six second-floor windows.

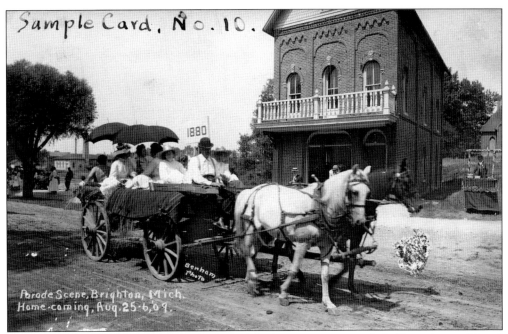

Around 1909, picture postcards were taken of the homecoming parade held on August 25 and 26. The parade welcomed back former Brighton residents who had moved to larger cities such as Detroit and Lansing. Horse-drawn carriages filled with residents celebrating eras past paraded up and down Main Street. Here, a group passing town hall represents the 1880s, as indicated by the sign. The building in the background, with the smokestack, is Brighton's first electric plant.

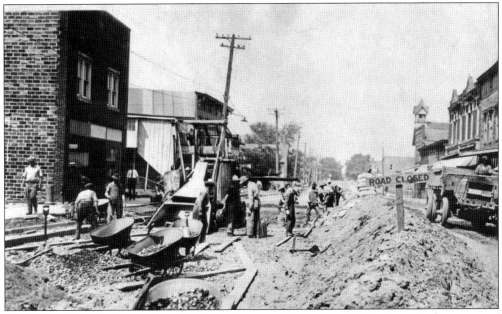

Never seen before by the people of Brighton, huge machines tear up Main Street in the process of laying sewers and paving the road in April 1924. Grand River Avenue and Main Street were most likely paved at the same time utilizing the same equipment, ultimately making it more affordable for Brighton. Rolison's Hardware sits to the left and is still there today.

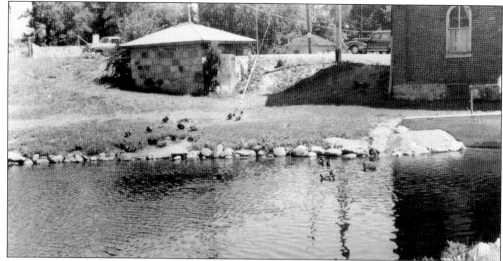

Pictured here in the 1950s, the old town hall stands to the right of the Millpond. The small stone structure to the left is the old Brighton jailhouse. It was built sometime in the late 1800s and was used until the population grew—and crime along with it. Note the person standing on the roof of the old jail.

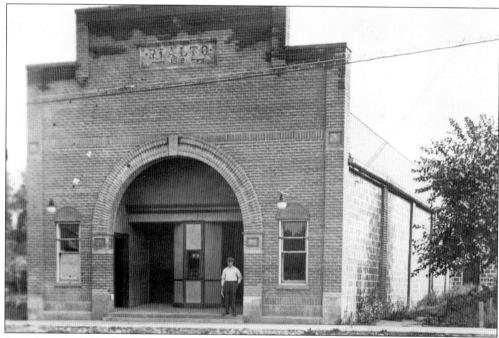

Seen here in 1918, the Rialto Opera House and Movie Theatre was built by Cliff Roberts. Construction started in 1918, but it took two years to build due to World War I. At the grand opening in March 1919, the Brighton Concert Band performed to a full house. The theater was complete with a stage, orchestra pit, dressing rooms, and the same projector model as theaters in Detroit. Later, a wireless radio was available to listen to sporting events, concerts, and government announcements. It was the first silent movie theater in Brighton. The Rialto also served as a community hall for school plays and high school commencement ceremonies. In 1937, it became a bowling alley called Brighton Recreation.

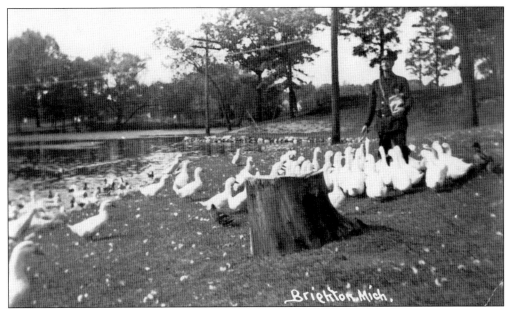

This rare 1950s photograph shows Burton Miller, police chief of Brighton at the time. His favorite pastime was feeding the ducks. The electric pole in the background is located where the current bridge or "tridge" (as it is called by Brighton residents, because it has three paths) runs over the Millpond. Today, downtown concerts are held at the gazebo located behind where Officer Miller is standing. The Miller Early Childhood Center at 850 Spencer Road was named after him.

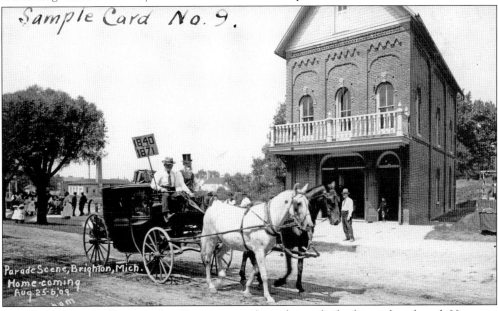

Pictured here around 1909, John Tanner is on the right, with the long white beard. He was a short man, only reaching five feet, but his beard was over six feet long. He would wrap his beard in paper and tuck it into his shirt and pants. Many people paid to see him reveal his famous long beard at carnivals. Henry Ford took interest in him. Tanner's hack "coach" (seen here) was later purchased by Henry Ford, and it is still on display at the Henry Ford Museum and Greenfield Village in Dearborn, Michigan.

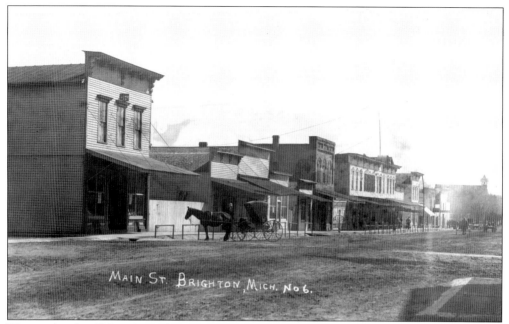

The north side of Main Street between First Street and the Millpond is seen here around 1905. Today, Stone Fire Bistro now stands on the corner at 440 West Main Street and Art Ventures is located at 422 West Main Street, where the brick building is seen to the right. The local Independent Order of Odd Fellows (IOOF) held its meetings at this location.

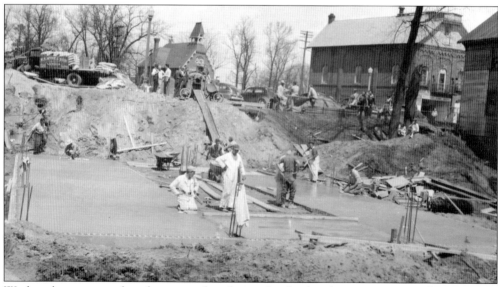

Workers lay concrete for a basement foundation for the fire department around 1948. Local merchant F.T Hyne and Son delivered building materials to the site; its truck is parked in the background. Excavation costs were minimized because of Ore Creek's low elevation. The building to the right was the "Deafy" Nelson stove store.

Two

GRAND RIVER AVENUE

The path that ran between Detroit and Lansing was a centuries-old trail used by animals, then Indians, then early settlers headed for Brighton. The Grand River Trail wound southeast to northwest through the center of the county, around lakes, streams, and rivers. In 1838, Allen Weston began the staging business over the Grand River Trail between Howell and Detroit. Stagecoaches were able to make the 90-mile trek in about 12 hours. Horse barns and inns popped up all along the route.

The Grand River Trail was wood planked from Detroit to Howell by 1850; by 1852, it was planked from Howell to Lansing. When the road was new, it provided a uniform, firm surface for wagons, stagecoaches, and carts. Since the plank road was a privately financed project, tollgates were erected every 5 to 6 miles. Tollhouses were located at Academy Drive and Challis Road.

The importance of the Grand River Trail to Livingston County paled in comparison to the impact of the railroad. Until 1871, the plank road was one of the principal thoroughfares of the state. It was the main route by which farm produce and other various items necessary for survival in the rural wilderness were delivered to markets. In 1926, Grand River Trail (now Avenue) was made a national highway known as US 16, and it was clearly the beginning of a new way of life.

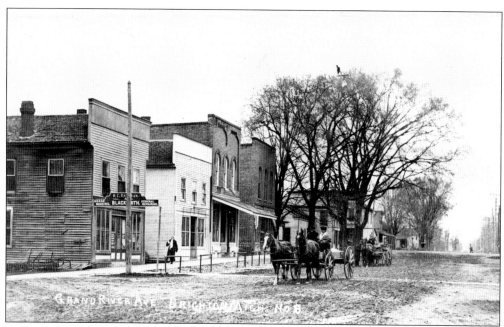

This shows the west side of Grand River Avenue between North Street and Main Street in the late 1910s. Today, the blacksmith building shown here at the corner of 140 East Grand River Avenue is the site of Champs Pub. The three buildings north of the blacksmith still exist.

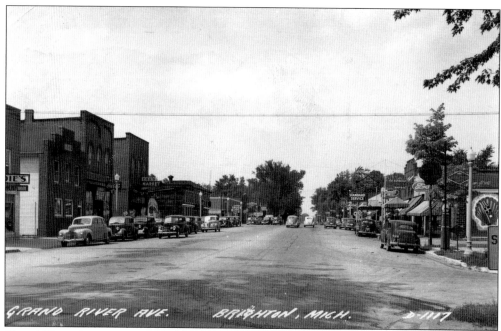

Grand River Avenue is pictured here in the 1950s. With paved roads, electricity, and cars, prosperity continued on an upward climb. Gas pumps and air-filling stations for cars were growing quickly. In this photograph facing north, a Shell sign is on the right; a Ford sign is on the building behind it.

In the 1940s, the east side of Grand River Avenue is loaded with businesses catering to the automobile. The Ford dealership on the right had two gas pumps out front. It is easy to see that Grand River Avenue was a highly traveled road between Detroit and Lansing.

Pictured here in the 1940s, Leland's Drugstore, on the corner of Main Street and Grand River Avenue at 100 West Main Street, was the first store in Livingston County with air-conditioning, called "frigid air." It also offered the modern convenience of 24-hour film development. Lu and Carl's occupies this space today. Built in 1926, the building across the street with the white stripe on top was the Canopy Restaurant, a famous landmark for Brighton. It was even rumored that the Purple Gang of Detroit dined at the restaurant when members were in town.

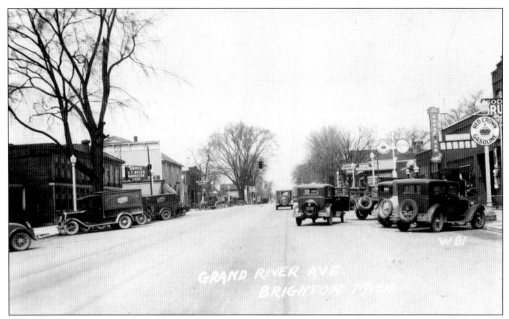

Grand River Avenue is lined with delivery trucks for the growing businesses in the 1920s. The trucks in the forefront to the left belong to the Northern Creamery Company. The C.F. Weiss Barbecue and Drug Store location on the corner of Main Street and Grand River Avenue is now Elias Realty. The two-story building behind the sign was the A&P. Only the first floor remains after a fire; today, it is Lu and Carl's restaurant. The sign farther down the street marks a car dealership called Willys-Knight Whippet.

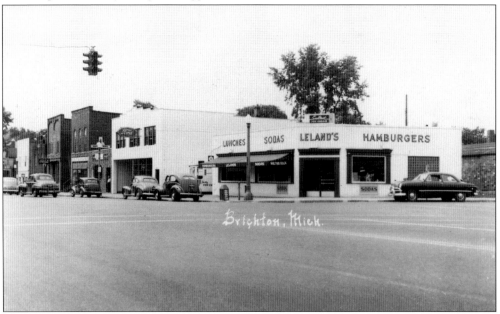

This 1950s photograph shows Leland's Hamburgers at 102 East Grand River Avenue, on the southwest corner of Grand River Avenue and Main Street. Today, the two-story building is home to Elias Realty. The Ford building to the left is now Bagger Dave's Restaurant, which displays many old photographs of Brighton.

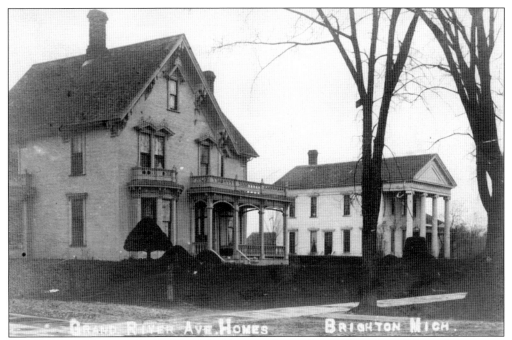

In this c. 1907 photograph, the Blatchford house is located at 324 East Grand River Avenue east of the Lee house to the right in the area that was known as Piety Hill. Blatchford worked as a veterinarian. Note the striking differences between the architecture of the Victorian Blatchford house and the Greek Revival Lee house. Prior to Blatchford, Dr. McHench lived in this house, which burned down in 1931. Blatchford later rebuilt another house in its place, which is now occupied by the VINA Dental Clinic.

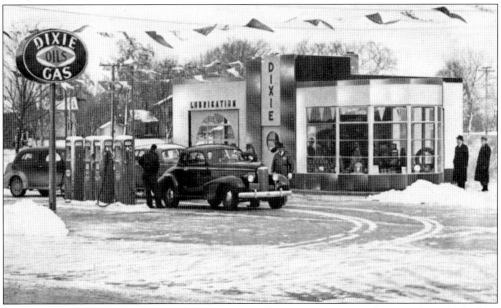

Pictured here around 1939, the Staebler station is on the curve opposite Rickett Road. In 1926, when Grand River Avenue became US 16, Rickett Road was a perfect location for businesses catering to the automobile. Travelers between Detroit and Lansing made use of the modern station.

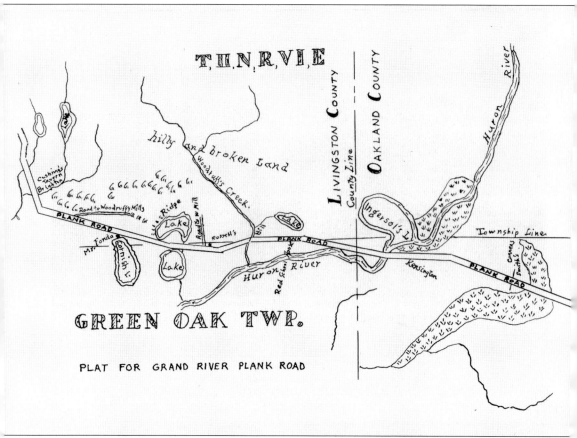

T.II,N,R,VI,E

LIVINGSTON COUNTY County Line

OAKLAND COUNTY

Huron River

hilly and broken Land

Woodruffs Creek.

Cushing's Tavern Brighton

G G G G G G G G G G G G G

G G G G G

Road to Woodruffs Mills

Ridge

Lake

Road to Mill

Russell's

Mr. Fonda

Cornish L.

Lake

Hur on River

Red River Post

Lake

PLANK ROAD

PLANK ROAD

Ingersoll's L.

Township Line

Canary Smith's

Kensington

PLANK ROAD

GREEN OAK TWP.

PLAT FOR GRAND RIVER PLANK ROAD

This c. 1830s map with the updated Plank Road (Grand River Trail) name shows the border between Livingston County and Oakland County. The Plank Road that runs through the middle of it is now Grand River Avenue. From Detroit to Lansing, the Plank Road was compiled of thick wood that made a more uniform surface free of the dirt-road potholes that plagued the stagecoaches and carts at that time. The Plank Road was completed in 1850. Ingersol Lake was expanded and is now called Kent Lake, which is part of the Kensington MetroPark.

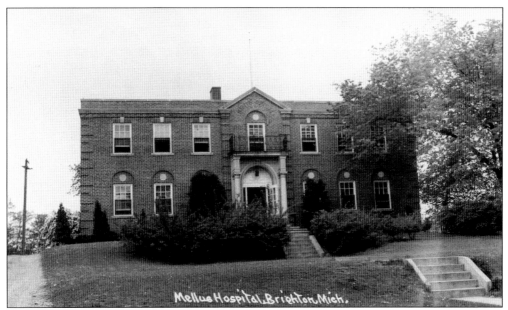

Shown here in the 1930s, the Mellus Hospital opened in February 1931. Located at 218 East Grand River Avenue, it brought more advanced medical care to the citizens of Brighton. The hospital was equipped with an operating room and an X-ray machine. In 1914, Dr. H.P. Mellus opened his first office, which was located on North Street behind today's Leaf, Barley and Vine. The hospital is now home to the Brighton Area Chamber of Commerce.

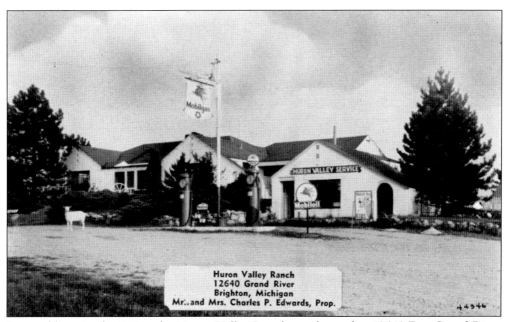

Pictured here in the 1930s, the Huron Valley Ranch was located at 12640 East Grand River Avenue. The Huron River is located south of the property, which is part of today's Island Lake State Park. The Huron Valley Ranch was located south of Grand River Avenue on the opposite side of the road from what is now the Brighton Hospital.

Seen in this c. 1910 photograph, the Avis home, located at 1025 East Grand River Avenue across from Kissane Avenue, is now the location of Dr. Sheng's Acupuncture Clinic. The Avis family owned and operated the Avis Sisters Ice Cream & Confection Shop at 108 West Main Street in 1910. Today, Sassafras occupies that building.

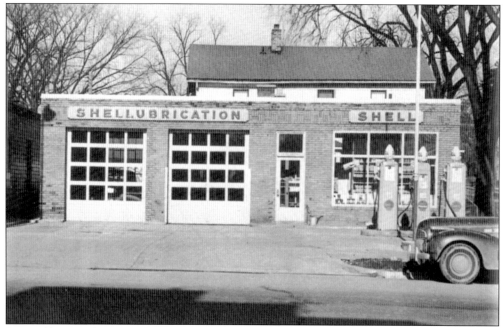

Pictured here in the 1950s, the Shell gas station on the northeast corner at 139 East Grand Avenue was owned and operated by the Bitten family. Leaf, Barley and Vine wine and cigar lounge now occupies the building.

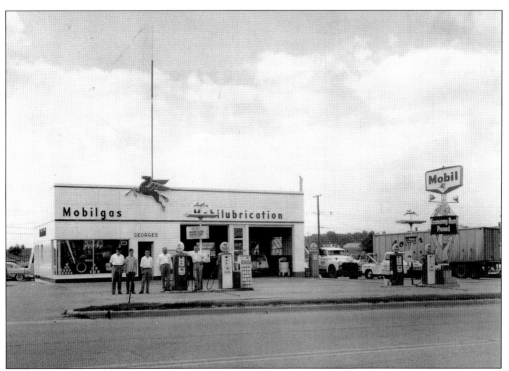

George's Mobilgas station at 9830 East Grand River Avenue is located across the street from where Brighton Chrysler Jeep Dealership now sits. Out front, the Schaffier family poses for a photograph in the 1950s.

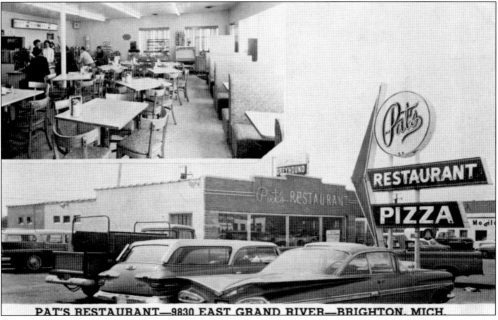

PAT'S RESTAURANT—9830 EAST GRAND RIVER—BRIGHTON, MICH.

Pictured here in the 1960s, Pat's Restaurant was a popular stop on Grand River Avenue. George's Mobilgas station is to the right. Pat and George Schaffier owned both businesses. The Greyhound depot offered a waiting room in the back.

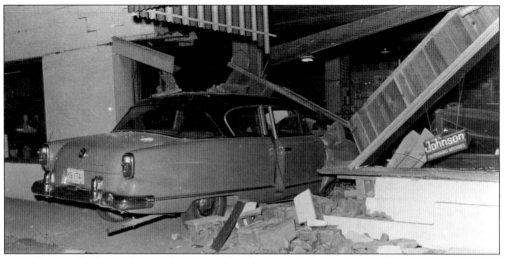

A car has crashed into the North Street side of Rosenbrook's Bait & Tackle shop in the 1950s. This car was leaving the Bitten Shell Station located across North Street. Most likely, the accident was due to an inexperienced driver. Accidents like this were a downside to the invention of the automobile. Today, Prudential Heritage Real Estate occupies this same building.

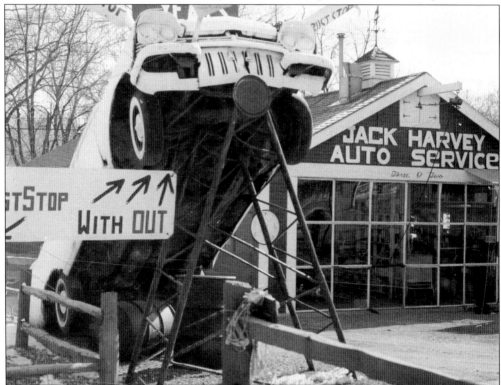

In the mid-1960s, Jack Harvey's Auto Service at 306 West Grand River advertises his rustproofing business. While it cannot be seen in this particular photograph, Harvey constructed a needle out of two 50-gallon drums. Harvey's business was located on the current site of Lawrence Auto Body. The Lawrence family did a complete rebuild of the body shop in 2001. Larry Lawrence is also a current member of the Brighton Area Historical Society.

Three

EARLY FAMILY HOMES
AND FARMS

Land acquisition was the motive for moving west to Michigan in the early to mid-19th century. For many, the opportunity to own land at an affordable price was worth leaving families behind to brave certain hardships in unknown territory. One of those pioneers was Maynard Maltby, a farmer from New York. He arrived in Michigan in the spring of 1832 with his younger brother, Almon. The brothers traveled the Indian Trail and followed markers burned into the trees. Maynard purchased 65 acres in what would later become the township of Brighton. In 1830, Stephen Lee arrived in Green Oak, where he built the first log house in the area. Other early settlers included Jessie Hall and Herman Lake, who settled in Hamburg in 1831. Elijah Marsh and Job Cranston were the first to settle in the township of Brighton in 1832.

The 1840 public census reports 786 people living in the township of Brighton. The foundation for the community was forming; growth was inevitable. As the settlement turned into a village, homes of the early settlers were handed down through the generations, which, in turn, continued to ensure the prosperity of Brighton's future. Word spread of Michigan's fertile soil, and more than four million acres of land had been sold in Michigan by 1836. Adaptable to inclement weather, wheat was essential to a farmer's survival. Good neighbors willing to exchange food, tools, and help were also essential in the isolated environment.

As the 20th century progressed, the accessibility of the automobile increased, and farm jobs were lost to factory jobs. As the 1920s approached, farms were sold off. Farmers were getting old, and their children were leaving to attend school or move to larger cities. Signs of the changing times appeared all around. Hitching posts disappeared from the towns, and automobiles pushed horses off the road. Brighton, like the rest of the country, was experiencing irreversible change.

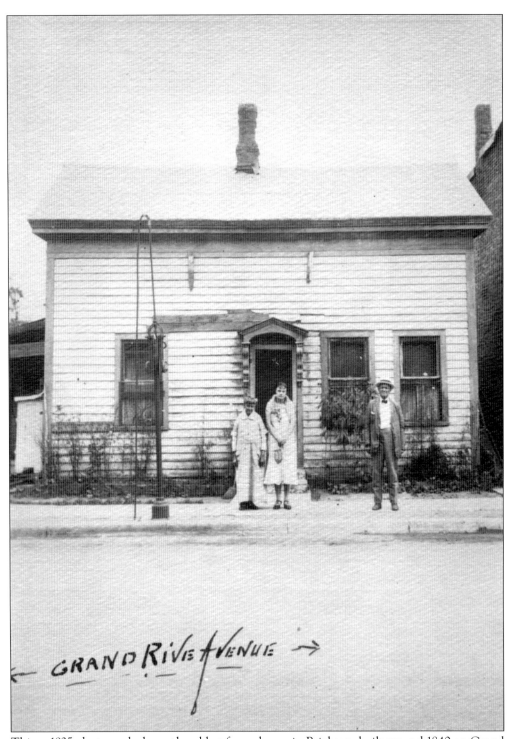

This c. 1925 photograph shows the oldest frame house in Brighton, built around 1840 on Grand River Avenue. The brick building to the right has Coney Joe's Restaurant located in the back at 116 West Grand River. Fred Stuhrberg (right) was born in 1860.

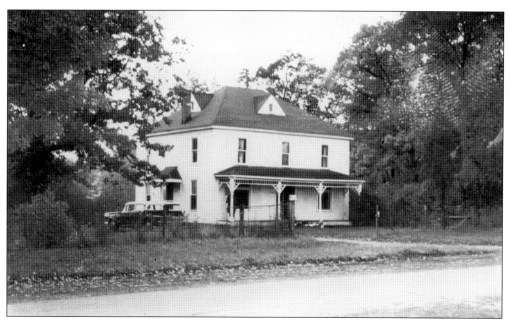

This c. 1960 photograph shows the Christa family home, built in 1875 at East Grand River Avenue and Pleasant Valley Road. This house stands on the site of what used to be a toll station for the early plank road in 1850. Today, the house is owned by Bert and Marieanna Bair. Marieanna has been the lifeblood of the Brighton Area Historical Society for decades.

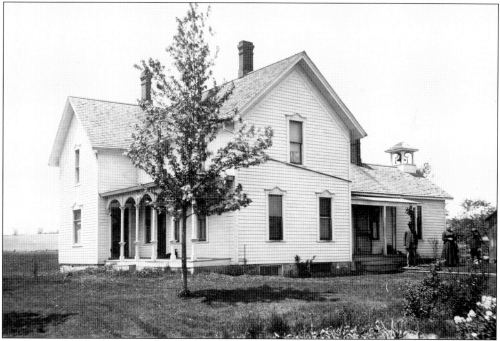

Pictured here around 1910, this house was built by R. Lyon in 1850 on Buno Road near Pleasant Valley. Lyon was an influential early settler of Brighton. The house was later owned by Henry, Lydia, and Ken Weber. Today, it is owned by Jim and Vicki Vichich. Jim is a member of the Brighton Area Historical Society.

Shown here in the mid-1980s, this house located on Spencer Road, east of Grand River Avenue, was built by Fredrick D. Acker in 1865. He came to Brighton in 1840 and also built the Presbyterian church in 1858. Acker served as the village trustee in 1869, and this house served as the office of the secretary of state in 1939. Today, Larry and Kate Lawrence own the home. Kate was the first female mayor of Brighton.

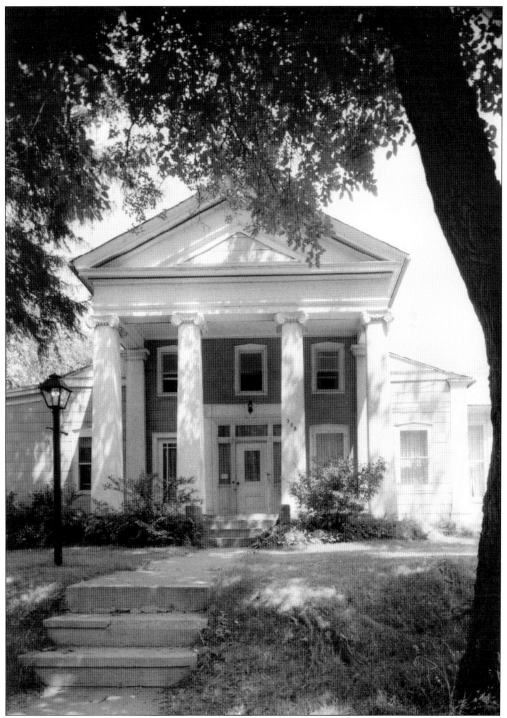

This c. 1965 photograph shows the J.D. Appleton house at 325 East Grand River, on the northeast corner of Grand River Avenue and Spencer Road. John Appleton, who was a carpenter and builder by trade, built the house in 1839. The home is still there today, and it is Brighton's oldest surviving house.

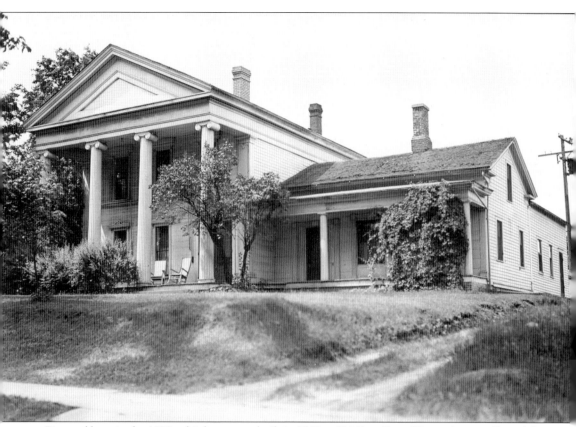

Pictured here in the 1930s, this house was built in 1840 at 314 East Grand River Avenue. Daniel S. Lee was the principal merchant of the village back in the 1840s and at one point was the wealthiest man in the county. He built this home, which was later owned by the Stuhrberg brothers. Lee was a friend of Gov. Lewis Cass, who made a campaign speech from the porch when he ran for president in 1848. This house was torn down in 1999.

In 1871, Charles T. Hyne founded a feed and grain company. Pictured here around 1913, this house was built in 1875 by Frederick T. Hyne, the son of Charles T. and the grandson of Godfrey Hyne. This house burned down in 1913. Located on the southeast corner of Main Street and Third Street, a Greek Revival–style house was built in 1914 at this location.

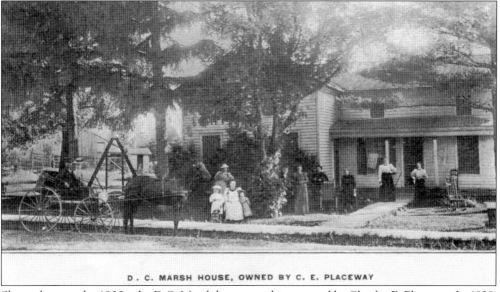

D . C . MARSH HOUSE, OWNED BY C. E. PLACEWAY

Shown here in the 1900s, the D.C. Marsh house was later owned by Charles E. Placeway. In 1839, Marsh was the town's first attorney. At only 20 years old, Placeway started the *Brighton Argus* on April 6, 1880. The home was on the northwest corner of Rickett Road and Grand River Avenue. Today, this is the site of Huntington Center.

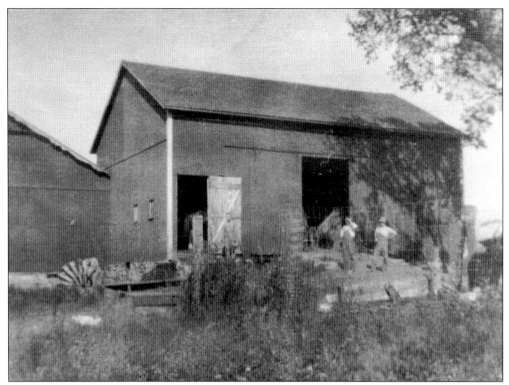

Pictured here around 1910, the Skeman family farm was located at VanAmburg Road and Skeman Road. Daniel Skeman bought the property around 1860 after he left Detroit, where he was a tollbooth operator on the early plank road between Detroit and Howell. The US 23 Expressway divided Skeman Road in two. Today, the east section at VanAmburg Road has been renamed Seitz Road.

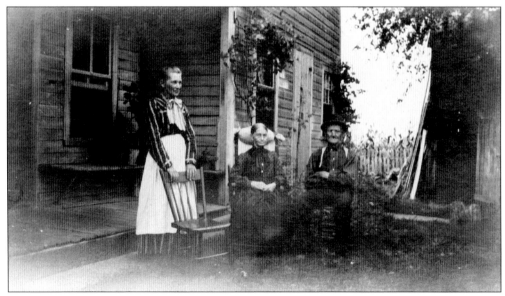

Pictured here around 1910, the John and Anna Bidwell home is located in Genoa township. Here, daughter Kate Bidwell Herbst visits her parents. This pose is typical of the period.

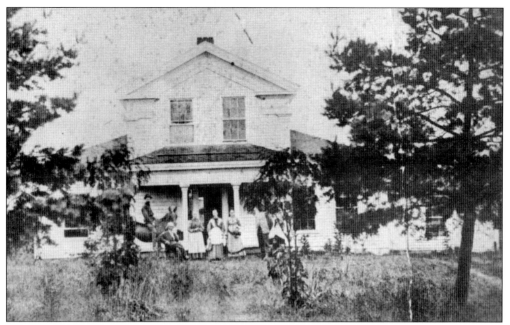

Pictured here around 1900, this home was built before the Civil War. Col. T. Vanderlip made this his family residence after he returned from the War of Rebellion. During the late 1890s, officers were housed here for training for the Spanish-American War. By the 1920s, it was known as the Louis Russell home, on the west side of Academy Drive and located south of the railroad tracks and Island Lake. This site is now part of the Island Lake Recreational Area.

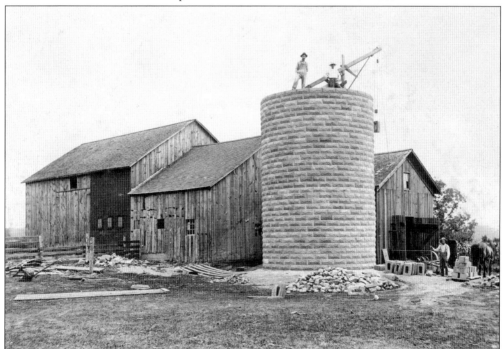

The Skeman family erects a silo around 1910 with the assistance of a crane. Curved concrete blocks were lifted and mortared into position. Silos were used to store a variety of grains.

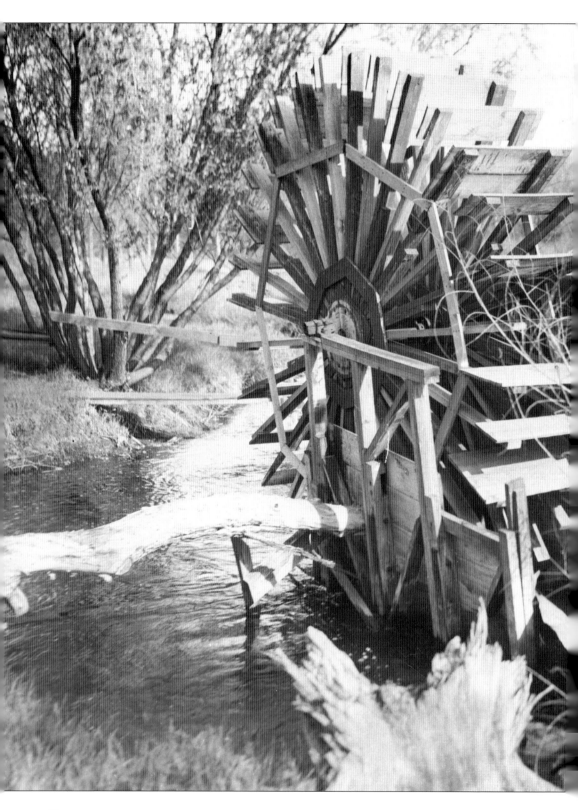

Pictured here in the 1930s, the old waterwheel located at the dam at Pleasant Valley and Ford Roads, on the edge of Woodruff Creek, supplied power for the mill. With its source north of Brighton township, the creek empties into the Huron River. Evert Woodruff was a very early settler in Brighton Township. He established his gristmill and sawmill on Woodruff Creek in the mid-1830s. The gristmill was at the northwest corner of Pleasant Valley and Ford Roads; his sawmill was about one half mile north, at Van Amburg and today's Toli Road. The sawmill provided lumber for the early homes in the township, and thus saved the residents long, arduous trips to Ann Arbor or Farmington to get needed lumber. Ford Road was named after William Ford, brother of Henry Ford, who had a large farm from the 1920s to 1960s that included the Woodruff Gristmill, years after it stopped milling grain. Today, all remnants of the mill have disappeared. The woman in the photograph is unidentified.

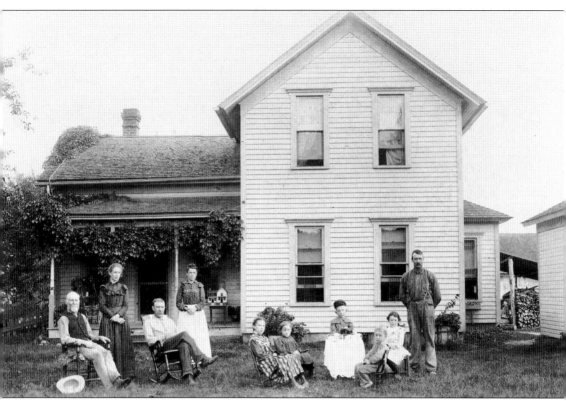

This c. 1902 photograph shows the Muir family home and farm, located on Buno Road east of Kensington Road. Pictured, from left to right, are Michael (Margaret's grandfather); Katherine (Margaret's aunt and a schoolteacher); James Michael (Margaret's father); Mary (James Michael's wife); Mae; Grace, William Joseph (eldest); Johnny; Margaret (the birthday girl); and Andrew (Margaret's uncle). Today, Tom and Mindy Kinsey own this house. Mindy is a member of the Brighton Area Historical Society.

Four

CHURCHES AND SCHOOLS

Even before the construction of churches for specific congregations, people of similar spiritual beliefs would gather in homes and barns to practice their faith. Rev. William A. Clark, DD, who came from New York in 1837, was the first to lead regular religious services. The importance of religious diversity is woven into the fabric of Brighton, as it offers a variety of churches for a diverse faith base. Brighton residents respectfully share the same community, regardless of what their religious convictions may be.

Built in 1850, Brighton's first frame schoolhouse offered writing, reading, spelling, and arithmetic. The Maltby brothers both played a large role in education, as they were both formally educated in their home state of New York. As the population grew, so did the need for more space and an updated curriculum. The Union School was completed in 1868 on Rickett Road across from St. Patrick's Church. It served as the high school for 60 years. A smaller building called the Lower School was built for the elementary-age children on the east side of the Union School in 1907. The Lower School is now an apartment building, but the Union School was razed in the mid-1950s. A new high school was opened in 1928 on the corner of Church Street and Main Street. Today's Brighton High School was built in 1966 on Brighton Road.

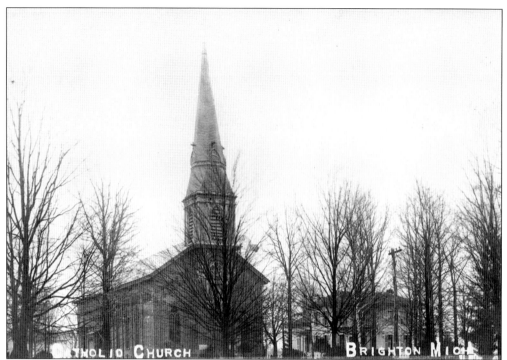

Pictured here around 1907, St. Patrick's Catholic Church was built on this property on Rickett Road sold by Ira Case in 1864. Subscription papers were circulated to raise money for the building, and Catholics and Protestants alike contributed. The church debt was paid off quickly, making it possible to build a rectory in 1876. The current St. Patrick's Church was constructed in the late 1950s.

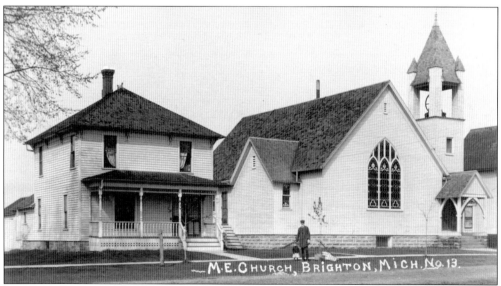

This c. 1910 photograph shows the First United Methodist Church, built on a hill on East Grand River Avenue by the Methodist congregation in 1856. In 1905, a new church with a seating capacity of 150 was built on the existing site. John McLucas was the religious leader from 1943 until many years after World War II.

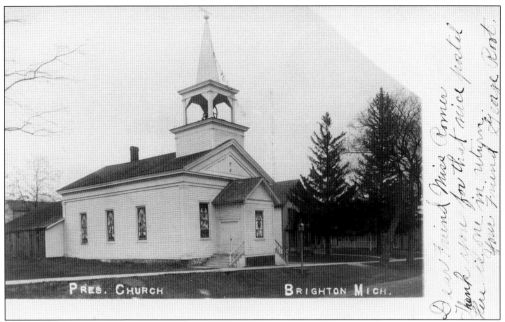

Pictured here around 1907, the First Presbyterian Church was built on East Grand River Avenue in March of 1858. This location was often referred to as Piety Hill because two churches were located there. In 1915, the Presbyterians consolidated with the First Baptist Church for economic and religious reasons and became known as the Federated Church. In 1927, the original church was sold and moved to West North Street to make room for the new church. An 1857 cornerstone was found during the demolition of the building. Among its contents was a paper stating that no slaveholder, or anyone who approved or defended the system of slavery, should be received as a church member or employee.

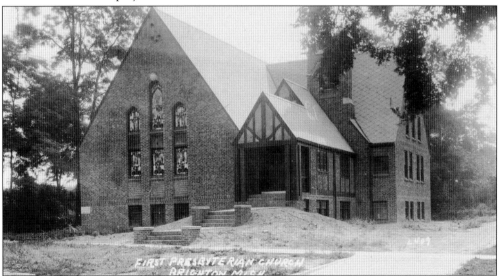

Pictured here in the 1930s, the Early English Gothic Revival Presbyterian building was completed in 1928 on East Grand River Avenue for $35,000. The original 1880 bronze bell was hung in the belfry of the new church. Pastor W.H. Simmons presided over the new church, and a new cornerstone was placed in the ground.

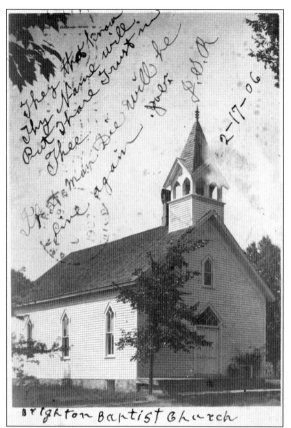

Brighton Baptist Church

Shown here around 1906, the Baptist church was erected in 1879. Prior to having a church of their own, the 25-member congregation conducted its services on Sunday afternoons in the Methodist Episcopal church. In 1915, they combined with the congregation of the Presbyterian church; and this religious partnership continued throughout the years.

The foundation and the cornerstone for St. Paul's Episcopal Church were laid in May 1880. James Collett of Green Oak won the bid to construct the new church, which was patterned after a church in England. Bishop Harris gave the beautiful rose window, installed on the south side facing Main Street. The Reverend William Clark's son Rev. John Clark held the first service on June 12, 1881. Pictured nestled next to the Millpond and the Village Cemetery in this c. 1906 photograph, it is perhaps the most iconic of the churches in Brighton.

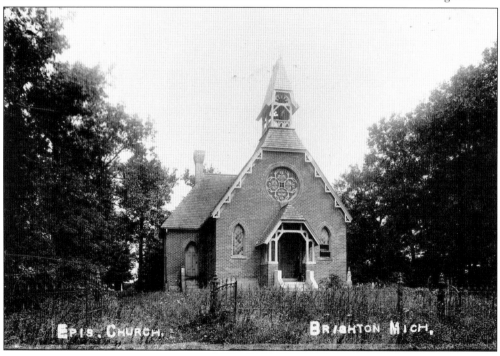

Epis. Church, Brighton Mich.

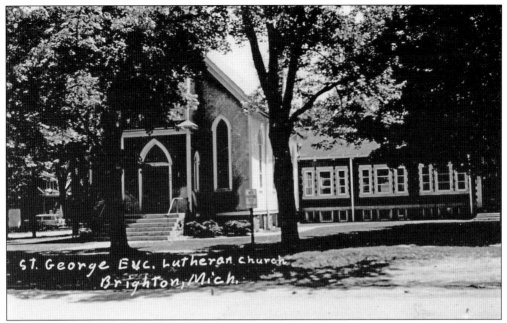

Before St. George Lutheran Church was built in 1848, religious services conducted in German were held in homes, barns, and rural schoolhouses. The church was first built on Dorr Road (Herbst) and Crooked Lake Road (Hubert) in Genoa township. Located at Crooked Lake and Bauer Road, a second church replaced it in 1879. Finally, in 1922, the building was dismantled and moved on a wagon to its final resting place, where it was reassembled on the corner of Fourth and Main Streets. St. George Lutheran Church is shown here in the 1960s.

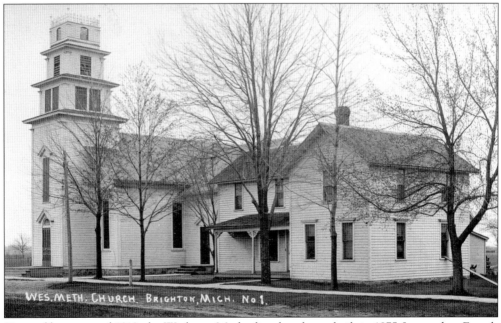

Pictured here around 1910, the Wesleyan Methodist church was built in 1875. Located on Fourth and Washington Streets, it was built on land provided by E.G. McPherson of Howell and cost $1,475. Ten years later, a bell was purchased to the belfry.

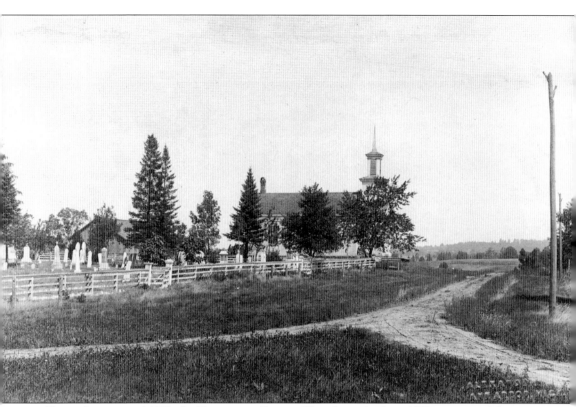

Shown here around 1912, the Kensington Baptist Church was built in 1853 just west of the town of Kensington on Kensington Road north of Grand River Avenue. The church was razed in 1952, but the cemetery still exists.

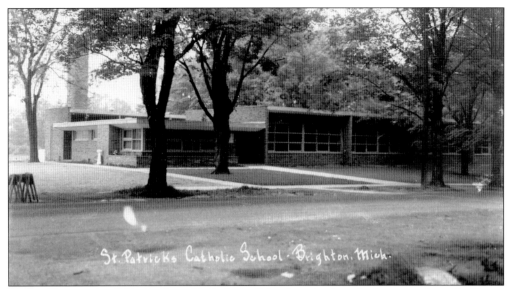

Pictured here in the 1950s, St. Patrick's Catholic School was built in the location where the Union School sat for 60 years. This modern school provided religious education for local children. The Lower School to the east of the Union School was built for the elementary children; it still stands as an apartment building at 620 Rickett Road.

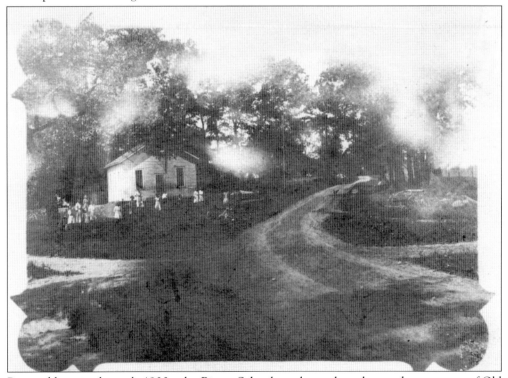

Pictured here in the early 1900s, the Bitten School was located on the northeast corner of Old US 23 and Hyne Road. It closed in the mid-1950s when the state law required that one-room schoolhouses consolidate with larger facilities in nearby cities. The school was relocated to the north and is now Schoolhouse Family Dentistry at 1255 South Old US 23.

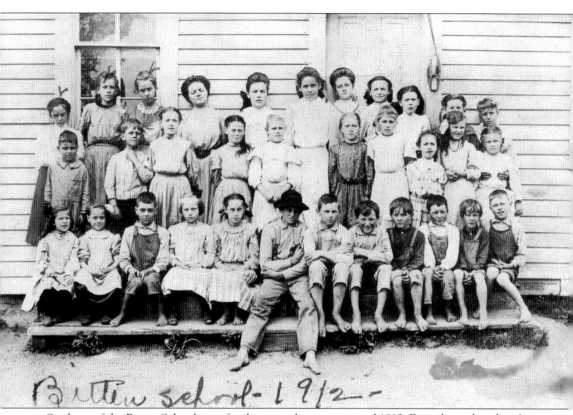

Bitten school 1912

Students of the Bitten School pose for the annual picture around 1912. Even dressed in their best clothes, most of them are without shoes. During the warmer months, it was not uncommon for children to walk to school barefoot.

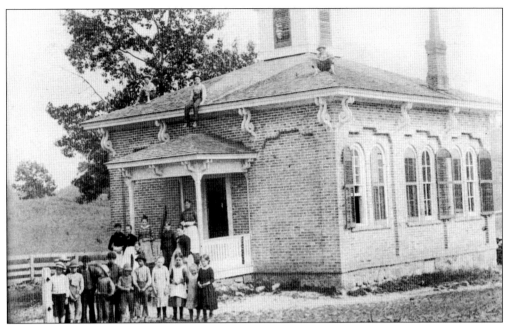

The Beurmann School was located across from Burroughs Farms on Brighton Road. Pictured here around 1886, the one-room schoolhouse is now a private residence. One can only guess how the three boys got up on the roof, or if the teacher is even aware of it.

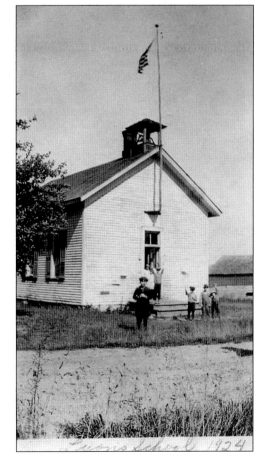

The Lyon School was built in 1885, replacing the log school built in 1842. Pictured here in 1924, it is located at 11455 Buno Road, formerly the main road between Brighton and Milford. The building to the right is the school's woodshed.

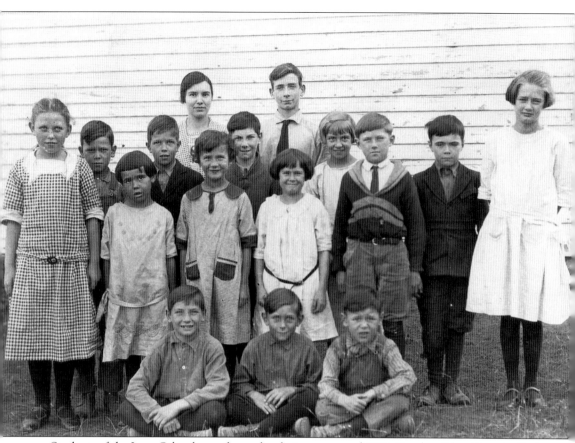

Students of the Lyon School pose for a school picture around 1922. Teacher Edna Chamberlin is standing behind the students. At that time, students attending one-room schoolhouses frequently walked a mile to school. When rural districts were no longer able to meet the needs of the growing community, rural schools closed, and the students were consolidated into modern facilities. Fortunately, Brighton Township offered the Lyon School to the Brighton Area Historical Society for a country school and headquarters. This effort was led by township clerk and Lyon School alumna Norma Jean Pless. The school has since been fully restored and is now preserved as a historical treasure of the community for years to come.

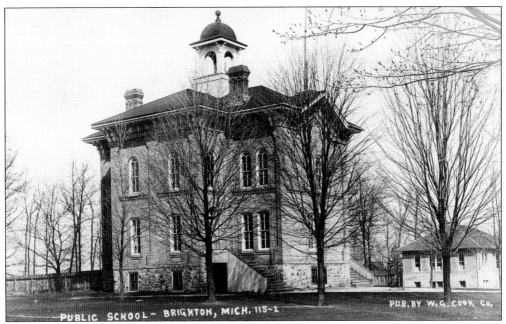

In 1868, only a few years after the Civil War ended, the Union School was built on Rickett Road. It took five years to construct. The faculty was made up of just two teachers. The final class to graduate from the Union School was the class of 1928. Shown here in 1907, the Union School served as Brighton's high school for 60 years.

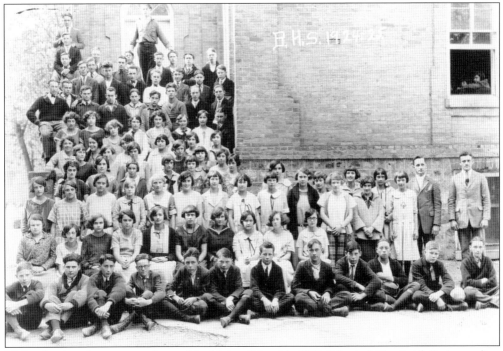

High school students pose in front of the Union School in 1924. Principal Don Leith Sr. is standing to the far right in the second row. In the 1920s, Leith started an ice-harvesting business, which gathered ice from nearby Lime Lake.

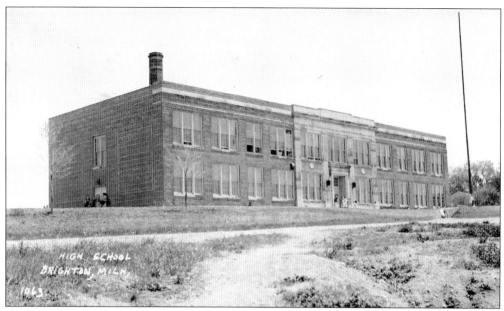

Pictured here around the time of its opening, the new high school opened in 1928 with just over 300 students on the corner of Church Street and Main Street. The school was considered modern for the times. The two-story structure was wired for electricity, complete with individual student lockers, and offered an updated curriculum. The principal was Walter Zemke. Today, this building serves as the administrative offices for the Brighton Education Community Center (BECC).

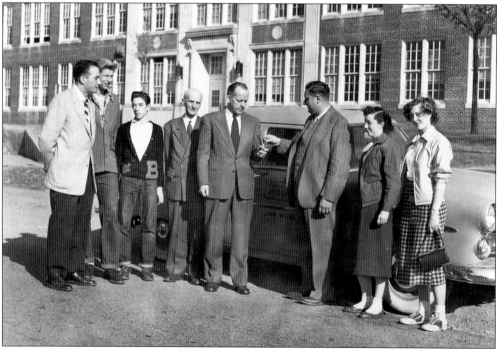

Principal Harlan Johnson receives car keys from John Weise around 1939. Weise, of the Weise Ford dealership, located at 110 West Grand River Avenue, donated a car for the school's new driver-education program. The Weise dealership site was the former location of the Eastern House.

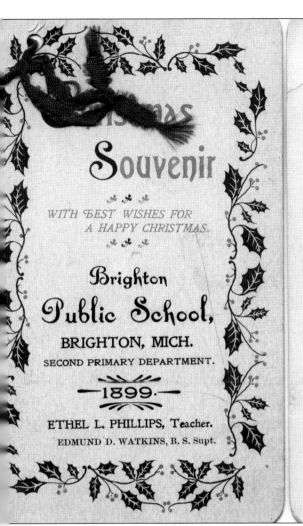

Souvenir

WITH BEST WISHES FOR A HAPPY CHRISTMAS.

Brighton
Public School,
BRIGHTON, MICH.

SECOND PRIMARY DEPARTMENT.

—1899.—

ETHEL L. PHILLIPS, Teacher.
EDMUND D. WATKINS, B. S. Supt.

Names of Pupils.

Grade Three.

Johnie Avis	Marjorie Judson
Raymond Bergin	Francis McCabe
Persis Cook	Jessie Paddock
Artie Fisher	Eric Reiner
Willard Fisher	Clifford Roberts
Glenn Hartmann	Mabel Ruxton
Albert Herbst	George Shannon
Gladys Hubbell	Elroy Spicer
Helen Judson	Annie Straus

Grade Four.

Nellie Bogan	Frank Kiehl
Vernie Fox	Mary Kiehl
Willie Holderness	Elba Rohn
Frank Hollister	Eddie Smith
Aurelia Judson	Ruth Thompson

Grade Five.

Carrie Avis	Tom Leith
Max Baetcke	Edna Matthews
Gliff Collett	Margaret McQuade
Louie Collins	Irley Merrihew
Florence Cook	Ethel Newman
Stanley Culver	Rex Reiner
Grace Dowell	Mildred Rohn
Anna Herbst	Floyd Spicer
Lizzie Holderness	Blanche Smith
Frances Hyne	Raymond Thompson

In this c. 1899 card, the Brighton Public School sends its best wishes for a happy Christmas. Grades three, four, and five all attended the Union School on Rickett Road—the only public school in Brighton at the time. Appearing on the roll are prominent Brighton family names. Many can be recognized as current street names.

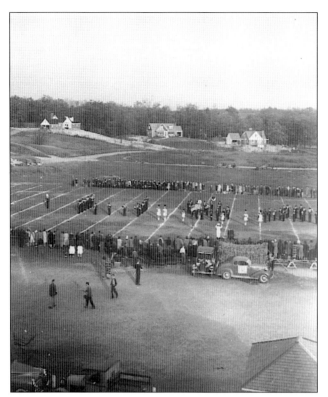

Sloan Athletic Field was built right behind the Church Street high school. Seen here in the 1930s, the field is still in use today for many high school sporting games; the houses in the background are also still standing. The road that runs through the back of the field no longer exits.

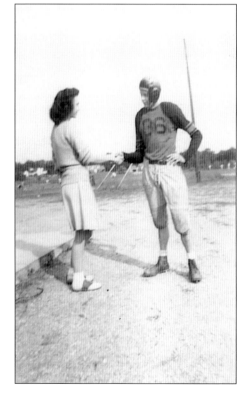

Edith Schreer, in her stylish saddle shoes, congratulates Raymond Falk on the Sloan Athletic Field around 1945. Note the football uniform with a leather helmet that lacks a face mask and has shoulder pads much smaller and far less protective than required today. Both were graduates of the class of 1945.

Five

TRAVEL

Early travel was difficult to say the least. Following the old Indian trail, a westbound trip from Detroit to Brighton usually took two to three days. A team of oxen pulling a wagon traveled at approximately two miles an hour. Settlers followed rough paths with only primitive tree-markers as their guide. Michigan's first roads were constructed after the War of 1812. In 1848, the state chartered a company to build a plank road. But the planks deteriorated quickly, and by 1855, the law was amended allowing the use of gravel instead of just planks. Even with these improvements, traveling by horse and carriage was time-consuming and uncomfortable.

Horses were no longer driving the country; it was steam. Eagerly anticipated by the residents, the railroad came to Brighton in July 1871. The possibilities of travel were endless with the new technology of the railroad. Businesses could expand, people could stay better connected, and rural isolation could become a thing of the past. By 1881, the stagecoach line from Brighton to Ann Arbor was discontinued. Brighton was experiencing the growth of the industrial revolution.

In 1900, there were 8,000 automobiles in the United States, and a third of them were built in Detroit. By 1905, speed regulation was made a state law. The bright lights of the automobiles were scaring the horses off the road—for good. In 1909, eight citizens in Brighton owned an automobile. By 1913, there were over 50,000 auto licenses issued in Michigan. Grand River Avenue was paved in September 1924, and by 1926, it was officially deemed highway US 16. General Motors Corporation purchased 1,075 acres of land near Brighton in 1924. The new proving grounds for automobiles provided a source of employment for Brighton. Change was here to stay.

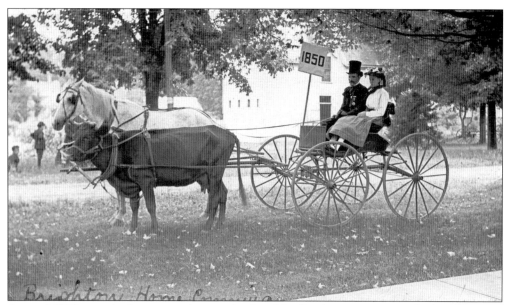

Around 1909, travel of eras gone by was displayed by Brighton citizens at the homecoming parade. Older-style buggies show how travel had vastly improved through innovation. Community residents were now embracing vehicles geared more towards their personal comfort, rather than traditional farm wagons.

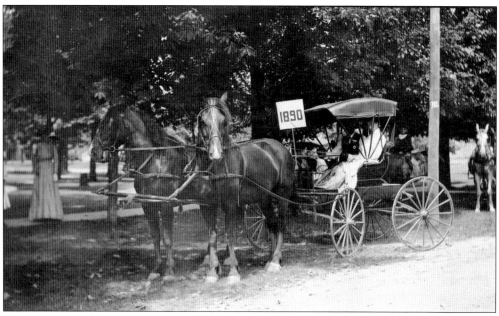

The 1890s were also represented at the c. 1909 parade. Continual changes in design of the coach and wheels helped reduce travel time and improve comfort. Onlookers stroll the sidewalks in the background.

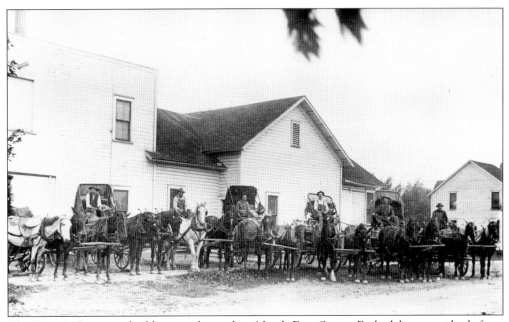

The Detroit Creamery building was located on North First Street. Early delivery methods from the farms to town took time and could only carry a limited amount of milk and cream because of space and weight. Here, wagons and drivers line up for a picture around 1910.

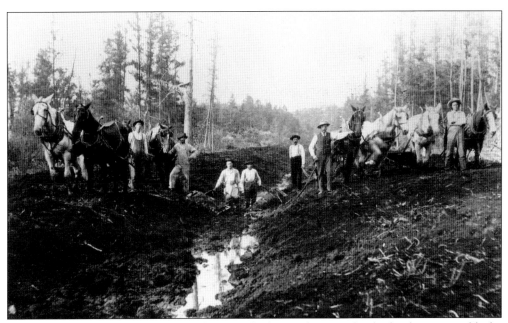

Around 1910, workers are building a drainage ditch in order to make the land more suitable for farming. Brighton is surrounded with lakes, ponds, and wetlands. Early construction was difficult due to limitations in the equipment and horses' strength and stamina.

This is the cover of the Detroit, Lansing & Northern Railroad Main Line schedule around 1884. Initial planning for the local railroad started in 1837, with actual construction starting 30 years later. The first passenger train visited Brighton on July 4, 1871.

This is the interior of the Detroit, Lansing & Northern Railroad Main Line schedule. The railroad eventually became the Pere Marquette. This c. 1884 schedule was recovered from within a wall of a house that was being remodeled.

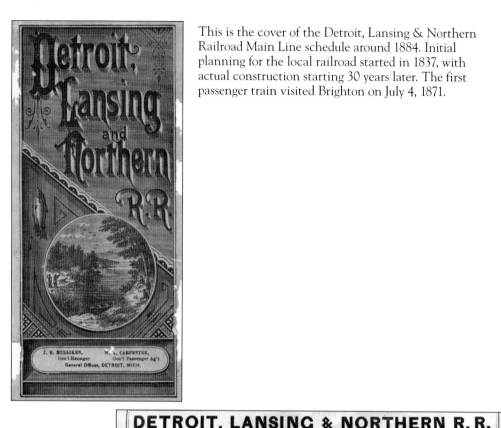

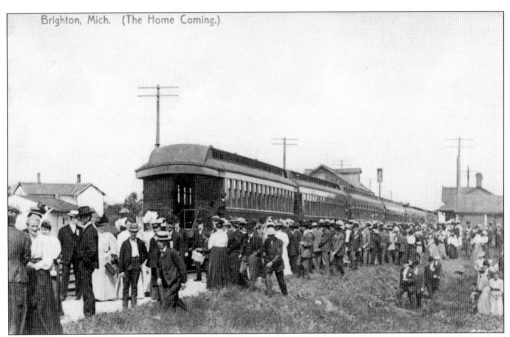

Brighton, Mich. (The Home Coming.)

Brighton citizens arrive at the train depot for a homecoming celebration around 1907. In the early 1900s, trains reduced travel time so people were free to visit longer and more often.

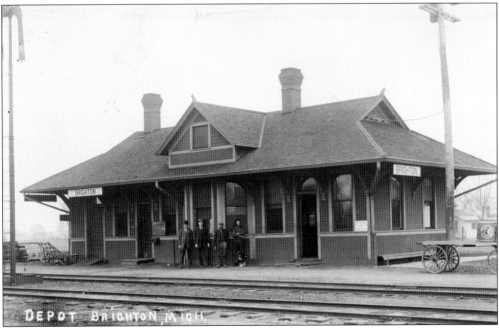

DEPOT BRIGHTON, MICH.

Brighton residents stand outside the Brighton Pere Marquette Train Depot located north of the Western Hotel in the 1910s. The depot was always bustling with citizens watching the train coming and going. It became a place for smiles on arrivals and tears on departures. The tall post with the ladder to the left holds the signal arm for the arriving train. The average total sales for tickets at this time were $1,000 per month. A trip to Detroit averaged about 4.5 hours and cost 65¢. The railroad had a huge impact on Brighton's prosperity.

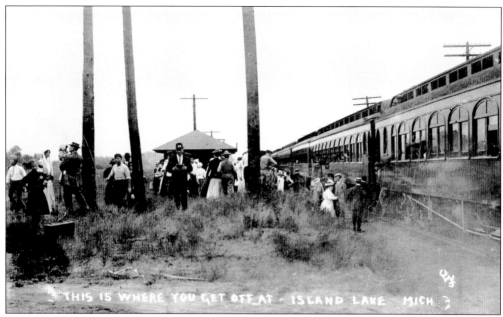

Pictured here around 1910, the station at Island Lake saw a large number of daily visitors to Island Lake Resort. The cost to travel from Brighton to the resort was only 10¢. Detroiters found Island Lake the perfect getaway from the busy city to swim and go boating. This was also the site where the soldiers for the Spanish-American War gathered and trained. In the foreground, Academy Drive is located just west of the training grounds.

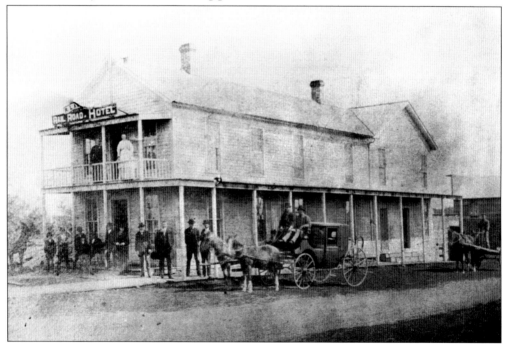

Shown in the late 1800s, the Lanning Hotel was built east of the railroad depot at 502 Cedar Street by Richard Lanning in 1873. The hotel later served as the P.G. Hartman residence until 1939. John Tanner is seated on the left on his stagecoach; his home still stands at 125 Beaver Road.

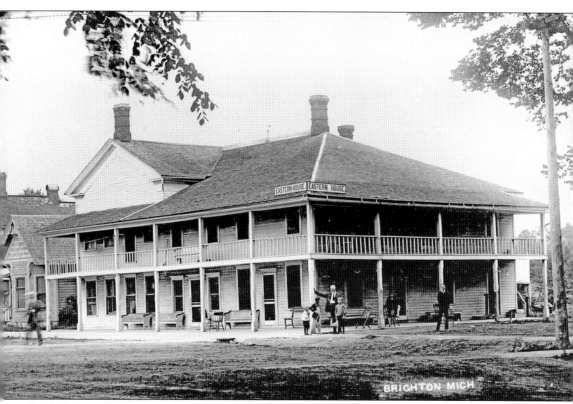

In 1838, Benjamin Cushing built the early Brighton House on the corner of Grand River Avenue and Fitch Street for stagecoach travelers, along with a 10¢ barn for horses. The election that made Brighton an incorporated village was held here in 1867. By 1892, the structure was owned by the Stuhrberg brothers and renamed the Eastern House. Here, Civil War veteran B.T.O. Clark leans against a post around 1905. The Eastern House burned down in 1926. Today, this site is the corner parking lot in front of the CVS drugstore and O'Reilly Auto Parts.

Pictured here around 1926, construction is underway by Tom S. Leith (above) on the Lincoln Hotel and First National Bank located on 130 West Grand River Avenue (below). Mill Street is now called St. Paul Street.

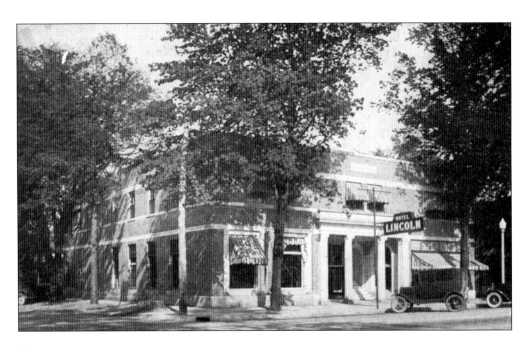

GRAHAM HOTEL
MR. AND MRS. R. V. GRAHAM, PROPS.
COCKTAIL BAR
BRIGHTON, MICHIGAN
"GREETINGS FROM THE GANG"

BOB — JACK — BERT — CHARLES — VAN

GREETINGS
and good wishes

In another photograph from 1926, the Hotel Lincoln was considered a fancy lodging in its day—complete with baths and hot water. In 1933, Robert Graham became the owner and changed the name to the Graham Hotel. It was later known as the Canopy restaurant. Today, the structure is the Premier Properties Real Estate building.

Shown here in the 1940s, the Log Cabin Inn Diner and Cities Service gas station was a welcome spot on the north side of Grand River Avenue between Brighton and Howell. The business is still on this site; today, however, it is only a restaurant.

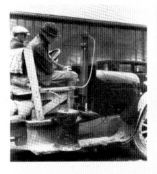

50th Anniversary Issue

EARLY TESTING PROCEDURES

Fuel economy was important back in 1924 too! But they used a 5 gallon can, two burettes, a bicycle pump, piping and tubing.

Back in the twenties, it took 2 men and one Coleman lamp to test undesirable glare from interior body trim; one man walked around, the other sat inside making notes.

Even in the early days, our cars had to withstand some tough testing!

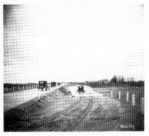

Delivery of ice blocks became easier for the Don Leith and Son's business with the improved design of automobiles and trucks, thus allowing for faster travel and larger loads in difficult weather. Here, Don Leith Jr. stands in front of his truck in the 1950s.

The GM *Proving Grounds 50th Anniversary Issue* takes a look back at the evolution of the automobile and its impact on travel. In 1924, the General Motors Corporation of Detroit purchased this property located in Oakland and Livingston Counties. This hilly terrain known as Bindernagel Heights was ideal for the various testing methods required in developing safe vehicles.

Pictured here around 1924, early testing procedures demonstrate the ingenuity of General Motors engineers as they developed the early testing methodology impacting the design and safety of this new means of transportation.

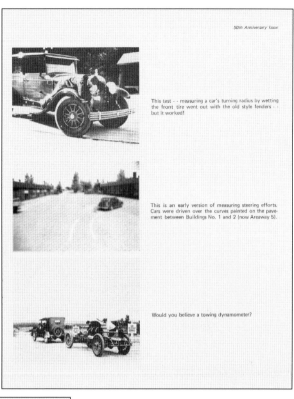

This test - - measuring a car's turning radius by wetting the front tire went out with the old style fenders - - but it worked!

This is an early version of measuring steering efforts. Cars were driven over the curves painted on the pavement between Buildings No. 1 and 2 (now Areaway 5).

Would you believe a towing dynamometer?

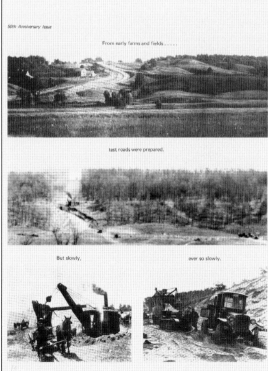

From early farms and fields

test roads were prepared.

But slowly, ever so slowly.

The proving ground road complex is being prepared for modern travel—carved out from the highest elevation in the two counties of Oakland and Livingston. These hills were shaped by glaciers that covered Michigan during the last ice age over 10,000 years ago. Simulations of road types and conditions provided real world experiences and were continually upgraded. The steam shovel and road equipment were recent innovations around 1924.

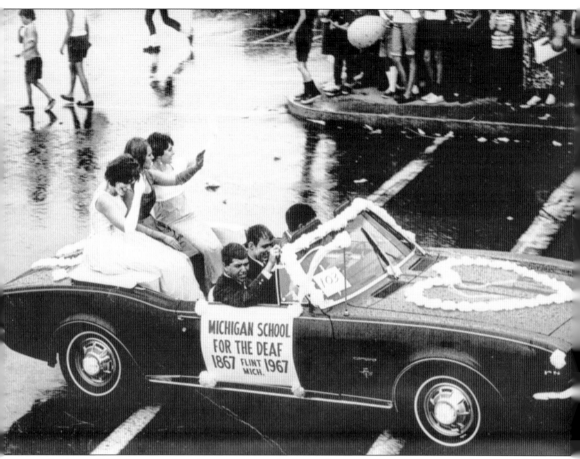

In this c. 1967 photograph, a downtown parade shows the continuing evolution of the automobile in style, comfort, and speed. The driver is Robert Wilkinson; his father was mayor at that time.

Six

EARLY BUSINESSES
AND ADVERTISEMENTS

After arriving in what would become Brighton in 1832, the Maltby brothers opened the first local sawmill on Ore Creek in the vicinity of Third Street and Franklin Street. Built by Orson Quackenbush in 1838 and located south of the Millpond, the first gristmill became known as Brighton Mills. The first foundry in Livingston County was built by 1843 in the vicinity of the Presbyterian church at 300 East Grand River Avenue. Other businesses were popping up, including blacksmiths, doctors, attorneys, and taverns. The spirit of entrepreneurship was alive and growing, with mutual support. While living in Brighton, professional journalist Fred A. Bush wrote a book of poems advertising the various businesses of Brighton in 1898. Argus, Town & Jacobs published the clever verses.

As the country changed with immigration, inventions, and wars, so too did the types of businesses. At one time, business owners could only operate during the day—until electricity made its way into Brighton in 1897. A country that once only catered to the horse and carriage quickly found a new way to make a living with the railroad, and eventually with the automobile.

After the stock market crash in 1929, the Brighton Businessmen Association (BBMA) formed in 1934. The Brighton Business district has historically experienced a steady growth pattern that still continues to this day. Early businesses did more than just shape Brighton's landscape or spur its economy. The foundation was laid through the generations of families that continue to give Brighton its own unique character and history.

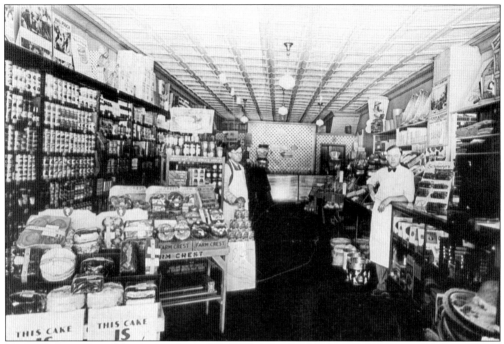

Shown here in the 1920s, Joe Brady stands on the left of Brady's Market at 431 West Main Street. Grocery shopping at these early markets was far different from what consumers experience today. Shoppers would give a list of items to the clerk, who would locate them, bring them to the counter, bag them, and complete the service with a handwritten bill. Today, Hush Intimate Apparel occupies this space.

Brighton Drug Store was located at 322 West Main Street. Its early-1900s ad for Dr. Kilmer's Swamp-Root Elixir is pictured here. J.J. Burniac Drugstore occupied the location from the early 1900s through 1945. Later, following World War II, Chuck Uber's drugstore occupied this building.

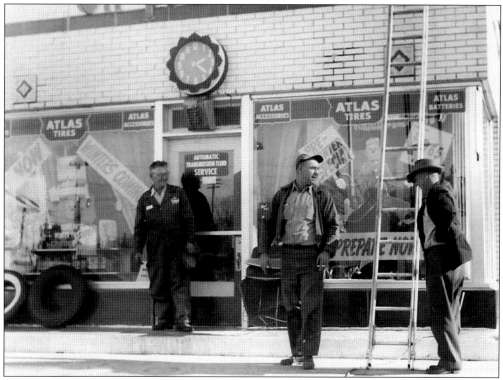

This c. 1952 photograph shows Greg's Standard Service at 600 East Grand River Ave on the corner of Rickett Road and East Grand River Avenue. Rickett Road was known as Ann Arbor Road and was the main southern entrance into town 20 years earlier. Brighton Travel is located on this site today.

This is a c. 1952 newspaper advertisement for Greg's Standard Service station. Gas service stations of this period provided tires, as well as the required tubes, oil changes, and car repair services. Note the scarecrow; deals are visible in the windows above.

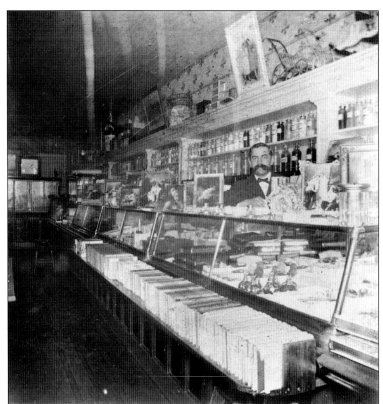

Pictured here around 1885, G.L. Pitkin's Drugstore was located at 113/115 East Grand River Avenue. In 1885, George LaRue Pitkin sold tea for 50¢ per pound and coffee for 20¢ per pound. In 1875, at the age of 19, he was a clerk at the drugstore owned by Otis Town and Company. This building is the present location of Portraits by Alex.

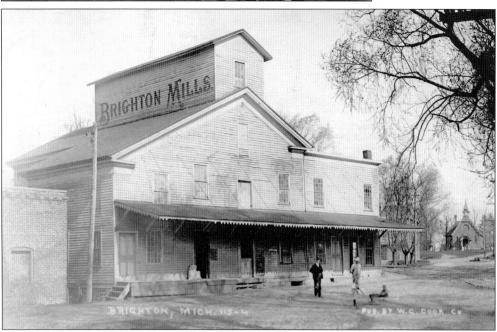

Brighton Mills was the original gristmill erected in 1838 by Orson Quackenbush. In this c. 1910 photograph, St. Paul's Episcopal Church is visible in the background. This is now the site of the public parking lot on West Street. The building was removed in the late 1940s.

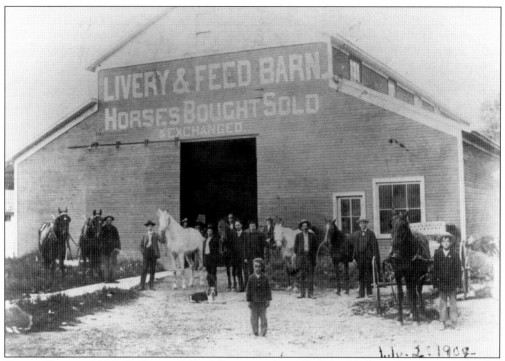

Pictured here in 1904, the Livery & Feed Barn was also called the 10¢ barn. It was owned by the Stuhrberg family and was located behind the Eastern House across the street from 114 East Main Street, where Mr. Ed's Barber Shop is currently located.

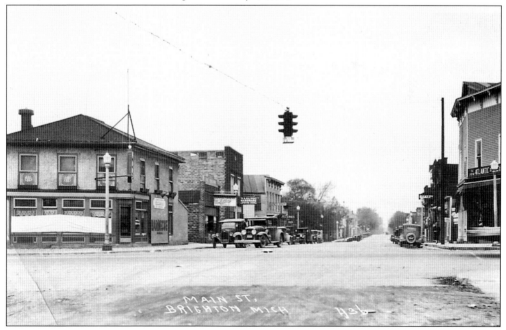

C.F. Weiss Barbecue and Drug Store (to the left) was located at 102 East Grand River Avenue. Shown here in 1926, its served soda and ice cream and specialized in barbecued meats. This is the current site of Elias Realty.

Ed Rosenbrook stands in his Bait & Tackle Shop on the southeast corner of North Street at 201 East Grand River Avenue in the 1950s. Today, Prudential Heritage Real Estate occupies this building.

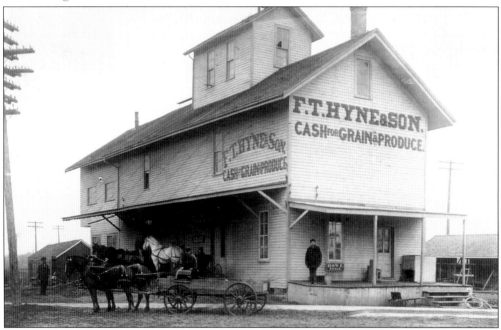

Local farmers could sell their grain and produce products at F.T. Hyne & Son Cash for Grain & Produce on 501 West Main Street. Pictured here around 1910, this was an ideal location just east of and adjacent to the railroad, providing easy access to distant markets. Buon Gusto restaurant is located on this site today.

This c. 1910 photograph shows Gus at his son Peter Hartman's meat market. This business followed their Hartman Saloon after it closed in the 1890s at 408 West Main St. Gus lived at 904 West Main St. Today, Brighton Bar and Grill occupies this building.

This c. 1920s advertisement is for the Boilore & Stuhrberg Meat Store on the southeast corner of Grand River Avenue and Main Street. The building was razed; it is now the site of Rottermond Jewelers at 102 East Main Street.

We are Here to Serve You

No order is too small or too large to receive our careful consideretion. Everything is Clean and Sanitary.

We Handle Only Quality Meats

Guarantee Everything Satisfactory
Let us fill your Sunday Dinner order.

A Full Line of Chickens

That is One of Our Best Specialties
BROILERS, FRYERS, STEWING
AND ROASTING CHICKENS

Boilore & Stuhrberg
On the Corner

This early 1900s advertisement is for E. G McPherson & Co. Clinch Back Suspenders. E.G. McPherson lived in Howell, and he owned substantial property west of the newly built railroad tracks, where homes were developed for settlers of Brighton. He also owned and operated a store at 334 West Main Street, where he sold his Clinch Back Suspenders along with other sundries and goods. Later, Strick's Department Store occupied this building. Fabuless Jewelry is found there today.

This c. 1940s paper cap came from a Plessland Farms Pasteurized Whipping Cream milk bottle. The Pless family owned and operated a dairy farm on Grand River Avenue. The Pless house is located 7219 Grand River Avenue and is now occupied by Grace and Porta Benefits. The dairy farmland, where Plessland Farms produced its whipping cream, is partially occupied by Dr. Bonine at 6893 Grand River Avenue today.

This c. 1954 advertisement is for George's Auto Service Station at 9830 East Grand River Avenue. Its former location is the present site of the Americus Coney Island restaurant just across from the Brighton Chrysler Dodge dealership.

This is a c.1890s advertising card for R.J. Lyon's Merrick Thread. Son of the earlier settler R. Lyon, R.J. owned a general store in Brighton. He was also a local schoolteacher. His former house still stands on Buno Road next to the Lyon School.

Pictured here around 1939, the Dixie Gas Station was located at 525 East Grand River Avenue close to where Tim Horton's corporate office is located today. The Rylander family owned this station. Many gas and service stations used this building into the 1990s.

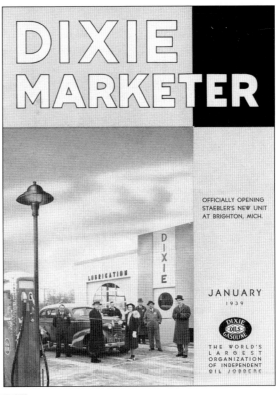

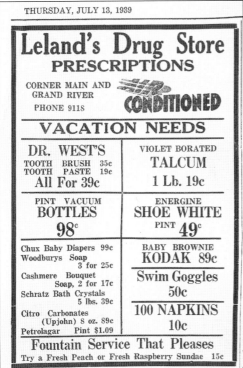

Pictured here in 1939, Leland's Drugstore was located on the northwest corner of Main Street and Grand River Avenue. Notice the four-digit phone number. Prior to his Brighton business, Robert A. Leland co-owned a drugstore in Howell. Lu and Carl's restaurant is found in this building today.

Plessland Originator

Frederick E. Pless and Elizabeth A. Grostic, married December 10, 1895. This picture possibly taken about five years later. They were parents of Louis, Harlow, Harriett and Frederick. Their home was midway between Howell and Brighton in the original Henry Andrew Pless homestead. Pless was a member of the Holstein Fresian Association and his large herd was registered under the name of Plessland.

tation of a Golden Eagle in front of his house of business, a significant mark of honor.

Due to political pressure and high taxes put on foreigners in Russia, he returned to Germany, soon after removed to Detroit, and then to Genoa, where he spent his last 35 years, and his wife Maria, lived there for 44 years.

They had had no experience in farming, and their survival had to depend on using funds they had intended to put into a business, and on the energy and determination of the children, especially the two oldest boys Lewis and Andrew, aged 12 and 11 respectively. Those two boys got off marriage until the other children were quite grown up. However, they were away from the farm when Lewis went to California to prospect for gold, and when Andrew returned to Germany to attend school there. Both were glad to get back home. The girls married, and all but one left the area, three spent the remainder of their lives in Lansing, one sister and brother went first to Jackson and then on to California, the other brother died at home at the age of twenty-six. Lewis married Julia George, and Andrew married Margaret Euler, both were the daughters of nearby pioneers.

In 1861, Lewis and Andrew bought the farm from their parents, and divided it. In the following years they each

Henry Andrew Pless, 1788-1876.

Maria Louise (Klesson) Pless, 1801-1885.

These early 1900s photographs show the Pless family history. In the top left are Frederick E. Pless and Elizabeth A. Grostic. In the top right is Henry Andrew Pless (1788–1876). In the bottom right is Maria Louise (Klesson) Pless (1801–1885). The Grand River home was the original Pless homestead. Henry Andrew Pless was a member of the Holstein-Friesian Association; his large herd was registered under the name of Plessland.

Pictured here in the 1950s, the Field-Dittrich DeSoto-Plymouth dealership, wrecker service, and gas station was located at 9987 East Grand River Avenue. Campbell's Collision has been on this site since 1969 and is currently run by the third generation of the Campbell family.

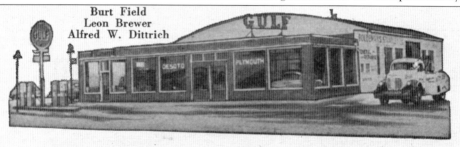

Seven

ISLAND LAKE AND OTHER SURROUNDING AREAS

Brighton's charm reaches far beyond its downtown. It happens to be surrounded by beautiful lakes, which make Brighton appealing to so many. It attracts visitors from all over with its social lake resorts and quiet rustic campgrounds. From early on, news spread about summer recreation at Island Lake. Tremendous numbers of people, looking to escape the crowded city, flocked to the lakes around Brighton in hopes of entertainment and relaxation.

Accessibility was a factor in the popularity of Island Lake. With a station conveniently located on the southeast side of the lake, visitors could effortlessly arrive by train, or they could travel by automobile on a smooth paved highway easily navigated from southeastern Michigan. Island Lake was a desirable spot that attracted tourists from all over, including sports heroes and famous gangsters.

Many Detroiters loved Island Lake so much, they wanted to build a summer resort to accommodate even more people. The Island Lake Hotel and Blue Lantern Pavilion were the places to be on a hot summer night with the sky full of stars. Dancing, boating, swimming, fishing, roller-skating, dining—Island Lake had it all.

Wetlands cannot be developed, so with so many lakes in such a small area, one finds a lot of untouched, natural land. It is just one more reason to stop and stay at Brighton.

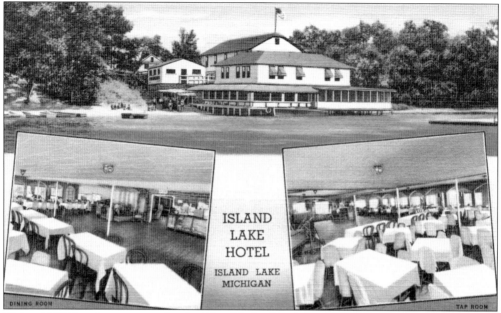

This mid-1920s advertisement for the Island Lake Hotel shows its lush accommodations. The resort had burned to the ground, and owner George Williams had quickly rebuilt this structure in 1922. This popular resort hotel provided diners a beautiful view of colorful sunsets, while the cool breeze from the lake was natural air-conditioning for summer visitors.

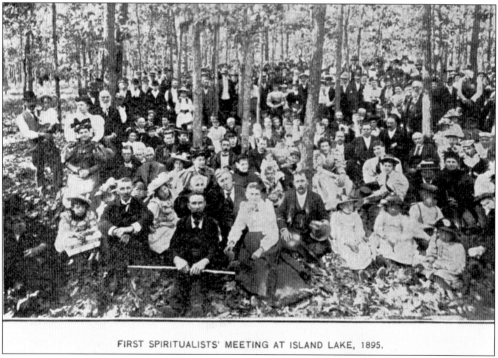

FIRST SPIRITUALISTS' MEETING AT ISLAND LAKE, 1895.

Shown in this c. 1895 photograph, the Spiritualists had a large following. Their meetings were first held in the woods at Island Lake before an auditorium was erected in 1896. Many of the Spiritualists came from Detroit.

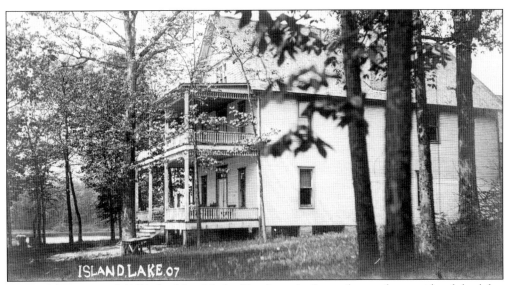

Pictured here around 1907, the Island Lake Hotel was built on the southwest side of the lake. The Spiritualist camp held regular séances in the auditorium, built in 1896 to communicate with deceased loved ones. The cost of speaking to a friend, spouse, or other relative through a medium was 25¢. Many guests enjoyed the challenge of swimming to the islands during the day, while they spent their evenings dancing at the Blue Lantern Pavilion.

Ice was harvested from Island Lake during the winter months. The icehouses, seen here around 1896 at the far edge of the lake, provided year-round storage. Weighing 250 pounds, ice blocks were shipped by train to markets in Detroit and Toledo. Many local farmers derived important income during the long winter months by cutting ice from the many lakes in the area with a special handsaw.

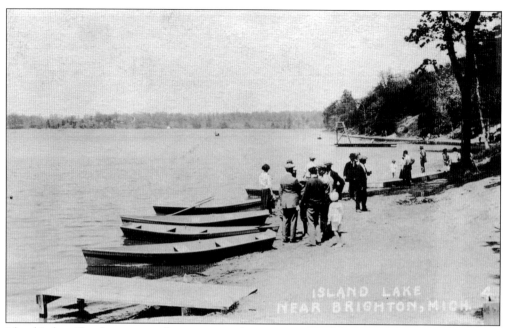

Island Lake offered many popular recreational activities; one of the favorites was boating across the water. Boats could be rented from the local hotels, and many young men saw this as an opportunity to show off their strength and endurance to the ladies in the 1900s.

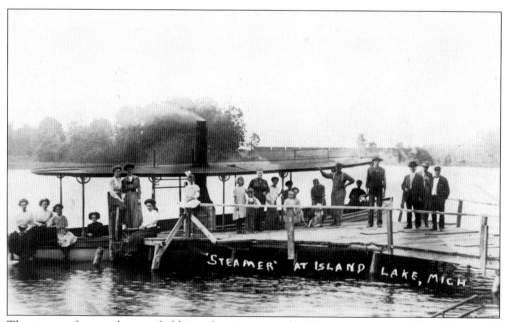

The steamer frequently provided leisurely trips across the lake to eager guests. This photograph was taken from the Grand River Avenue side of the lake around 1907. Visitors frequently came by train and stepped off at the Island Lake Depot across the lake at Academy Drive. Boxcars are visible in the background.

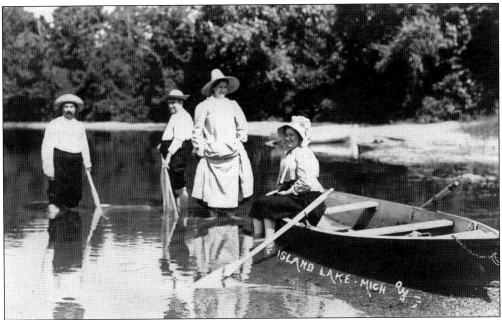

Guests relax by the shore and bare some skin on a hot summer day around 1910. The men are using a net to catch minnows to use as bait. The women are wearing typical recreational clothes of the period.

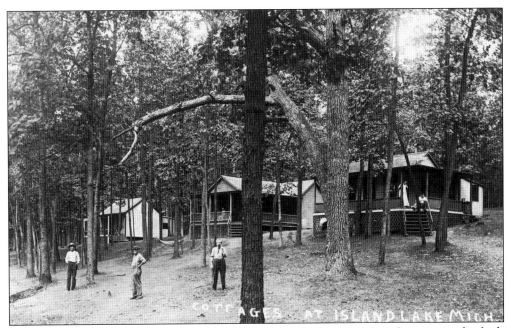

Pictured here in 1910, the cottages of Island Lake were small but inviting. Camping in the fresh air in the peaceful setting of these cabins provided a welcomed break from the noisy, industrial city. The proximity of the cabins allowed for many enjoyable social encounters. These cabins were located near the Spiritualists' camp.

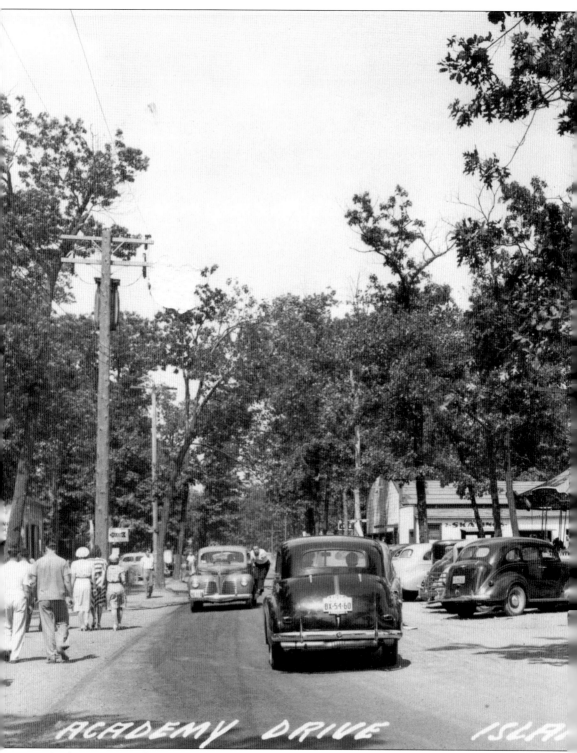

In the 1940s, Academy Drive was located by what is now the Cozy Inn bar. Traffic often backed up for miles on Grand River Avenue trying to get to the Academy Drive park entrance. Island

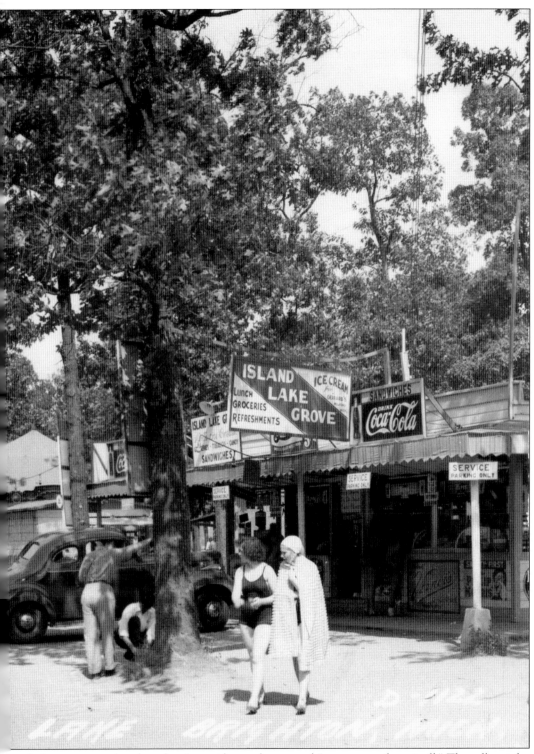

Lake was a popular place for city residents who wanted "to get away from it all." The roller rink is in the background on the right.

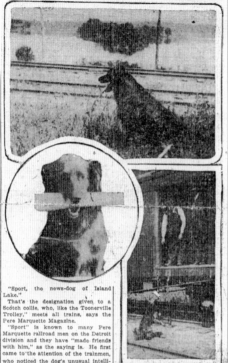

"Toonerville Trolley" Up at Island Lake Is a Collie Dog

"Sport, the news-dog of Island Lake."

That's the designation given to a Scotch collie, who, like the Toonerville Trolley," meets all trains, says the Pere Marquette Magazine.

"Sport" is known to many Pere Marquette railroad men on the Detroit division and they have "made friends with him," as the saying is. He first came to the attention of the trainmen, who noticed the dog's unusual intelligence and began to teach him to carry a newspaper in his mouth as other dogs are taught to scurry off after a stick. Since then it has become a habit with "Sport" to watch for the arrival of the trains and then run quickly with the latest edition to his master's home, which is but a few hundred yards from the station.

Trains 8 and 17—the Grand Ledge and Detroit accommodations—"Sport" invariably awaits with manifest impatience. He seems to know their running time to the minute and will rush from a distant field to be there on the dot. Conductor Charles Hinds and his men seldom disappoint him. If the train stops at Island Lake, they give him the newspaper, or if their train happens to run through, they throw it off carefully tied.

With the regular and even the occasional travelers on these two trains, in particular, it has become an interesting experience to "look out for 'Sport'" when the train reaches Island Lake."

Only a short while ago, a traveler who had business in the town and who was on board a fast train which did not stop, resorted to a clever expedient to inform a customer that he would return the next day. He tied a letter to a newspaper and threw it off for "Sport" to pick up. The plan worked successfully and the collie's master saw to the proper delivery of the letter when it was brought to him.

All summer "Sport" looked after the comfort of the resorters at the lake. Each morning he made the rounds of every cottage as though he wished to see that everything was going well with them. He is nearly two years old and is owned by Mr. Fred L. Russell.

Sport the collie was a regular sight up at Island Lake resort. Pictured here around 1920, Sport was the Island Lake newspaper delivery system for his master, Fred L. Russell. Sport knew the train schedule and run times, and waited impatiently for them to stop to give him his master's newspaper. The train conductors commented on his intelligence. Sport was a welcome addition, making his rounds while dutifully keeping his eye on the place.

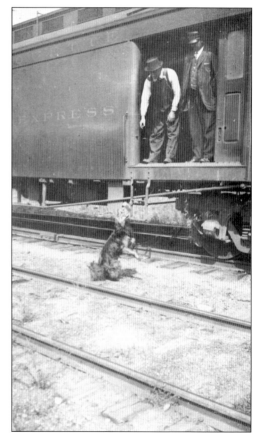

In this c. 1920 photograph, Sport takes the latest edition of the newspaper from the Pere Marquette train conductors to his master.

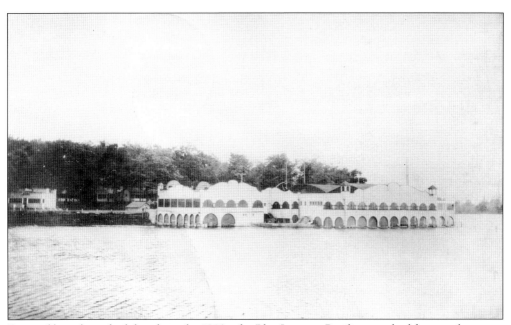

Pictured here from the lakeside in the 1920s, the Blue Lantern Pavilion reached far over the water. With the orchestra music playing, couples dancing, and lights shining off the water, it is easy to see why so many people flocked there for so long.

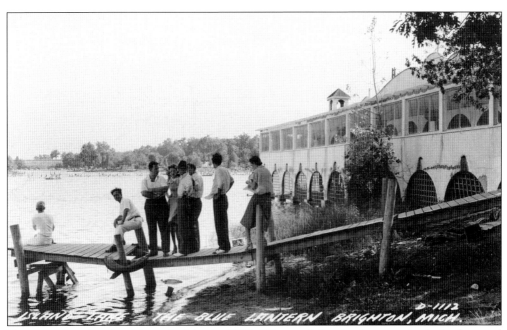

Here, people enjoy the rickety dock in the 1930s. The small dots in the water in the background are the hundreds of people swimming in the lake at the state park. The railroad grade is visible in the background.

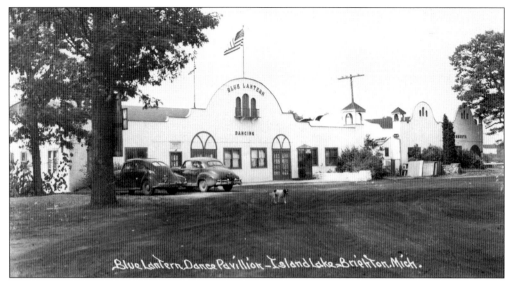

Blue Lantern Dance Pavilion—Island Lake—Brighton, Mich.

Work by C.W. Burton Co. on the Island Lake Pavilion began in 1921. Shown here in the 1930s, it was a beautiful site, decorated in gold and blue. Its lights sparkled off the lake at night. The estimated cost of the pavilion, with its unique design of extending out over the water, was $30,000. It was known for having one of the best dance floors in the state. In 1925, the pavilion was renamed the Blue Lantern.

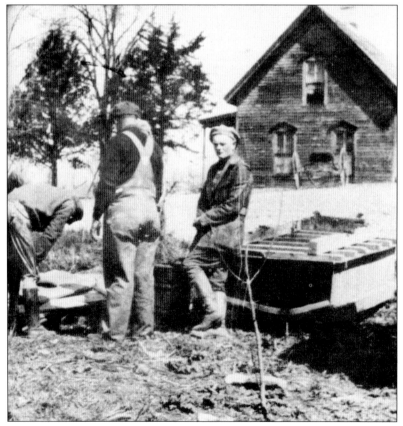

The house in the background of this c. 1923 photograph was located at 10816 East Grand River Avenue where the Bank Shot Pool building is today. A member of the Purple Gang of Detroit owned it. The house was later moved to Hope Street.

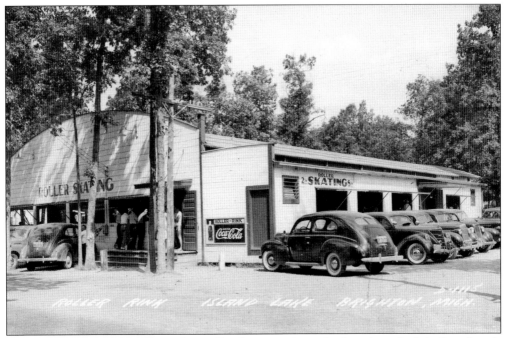

Pictured here around 1930, an indoor roller-skating rink was built and run by Lyle Seat. Locals and young people enjoyed this form of entertainment. In the mid-1960s, the roof collapsed from excessive snow, and the business closed permanently.

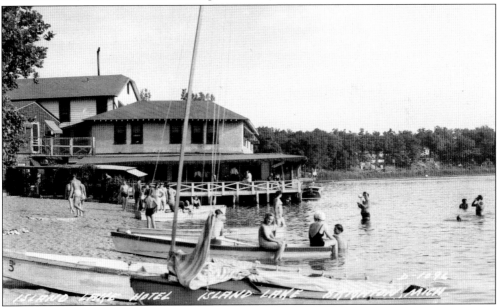

Pictured here in the 1920s, the three-story Island Lake Hotel was built on the east side of the lake in 1920. It burned down in September 1921 but was immediately rebuilt in the same location by February 1922. It was a favorite place of Babe Ruth's when he was in town with the New York Yankees. In 1922, he missed a banquet in Detroit held in his honor because he was at the Island Lake Hotel having dinner with Gov. Alex Groesbeck. The Babe was often seen playing ball with local boys, and he was even issued a ticket once for fishing without a license.

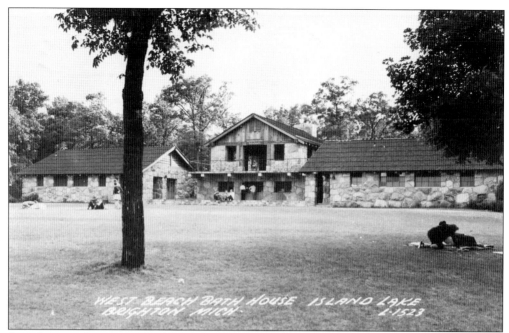

Seen here in the 1930s, the bathhouse and pavilion at the state park beach were located on the south west side of Island Lake. The large boulders came from the Leitz family farm in Brighton township.

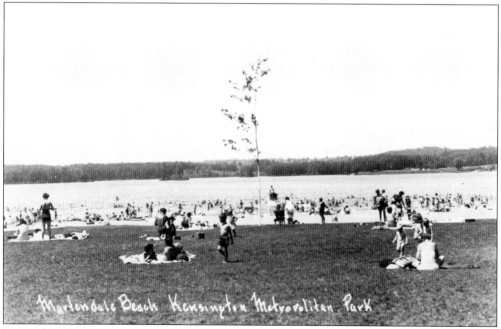

Located on the east side of Kent Lake, Martindale Beach at Kensington Metropark is pictured here in 1960. The Huron Clinton Metropolitan Authority was made possible by an act of the Michigan Legislature, and the first board was appointed in 1941. The park offers year-round activities, including swimming, boat rentals, food service, nature trails, sledding, and toboggan runs. This beach is still very popular today.

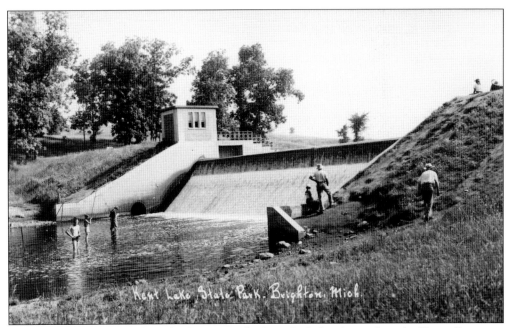

Some young boys enjoy fishing by the Kent Lake State Park dam located on the Huron River just south of Kensington Metropark in the 1950s. The dam, built in 1948, expanded the lake from 60 to 12,000 acres; the river flows into Lake Erie. Fishing is still very popular there today.

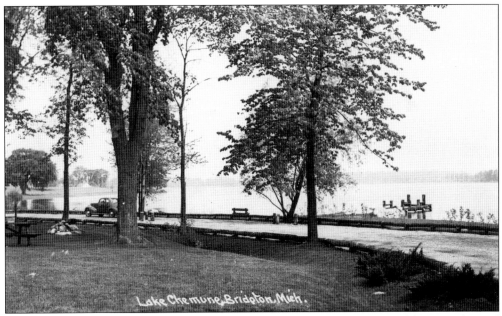

This photograph shows Lake Chemung in the 1940s. It was taken from the public access located between Brighton and Howell on Grand River Avenue across the street from the Champion Chevrolet dealership. Cottages still line the shores, but many have been transformed into year-round homes. The lake is located behind what is Wilson Marina today.

Pictured here in the 1940s, Little Crooked Lake, also known as West Crooked Lake, is located north of Burroughs Tavern on Brighton Lake Road. The Oak Point housing and golf course development is also on this lake, and in the 1920s, a canal was dug to connect Big Crooked Lake to Little Crooked Lake.

Shown here in the 1940s, School Lake is located east of Old US 23 and north of Skeman Road in Brighton. Once named Warner Lake, then Hick's Lake, it was finally called School Lake for the one-room Bethel School located on its shore.

Shown here in the 1940s, Winans Lake is located south of the Brighton State Recreational Area in Hamburg township on Chilson Road. It was named after the family of Edwin Winans, who was the governor of Michigan from 1891 to 1893.

Shown in this c. 1940s photograph, Woodland Lake is located east of Grand River Avenue and north of Hilton Road. It was formed when a dam was built on Ore Creek in 1928. Meier Flowerland and Greenhouse is located on this lake at 8087 West Grand River Avenue.

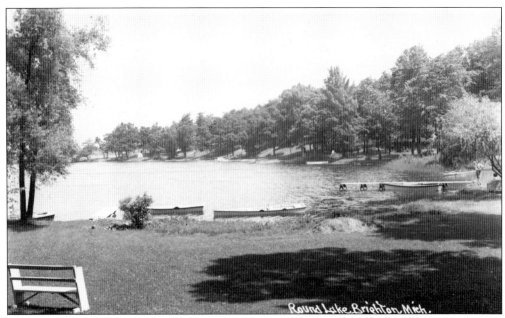

Round Lake, also known as Clifford Lake, is visible here in the 1950s off of Clifford Road north of the Oak Point development. The first cottages on this lake were built in 1913. This lake is adjacent to the two Crooked Lakes, and the locale is referred to as the "Tri-Lake" area.

In 1832, Lewis B. Fonda purchased the land pictured here in the 1950s. Eventually, he built a farm and a home on the north shore of Fonda Lake. When he started building, he noticed the marks left from Indian wigwams that once stood around the lakeshore in the summer.

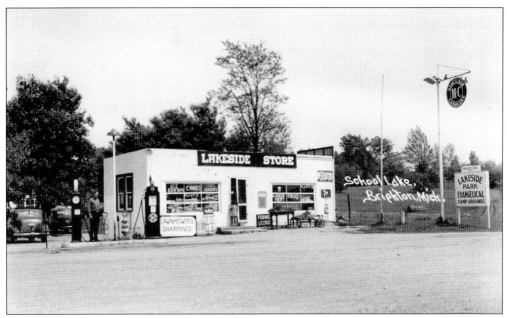

The Lakeside Store and Service Center is located next to School Lake at 322 Old US 23 at the southeast corner of Skeman Road. In this c. 1947 photograph, the gas service attendant stands patiently in between the pumps, and a girl enters through the front door. The sign to the right mentions the nearby Lakeside Park Evangelical Campgrounds. Old advertisements are abundant on the building, including Pepsi-Cola, 7Up, and Sinclair Gasoline.

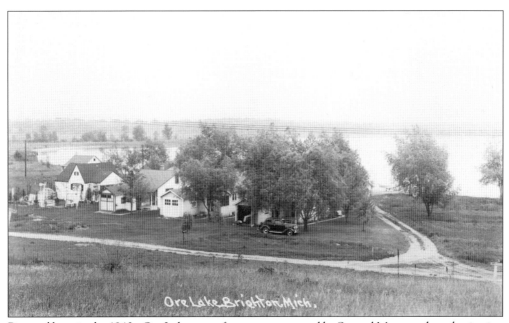

Pictured here in the 1940s, Ore Lake water frontage was owned by Samuel Moon and was beginning to be developed by 1915. It is located west of Huron Meadows Metropark.

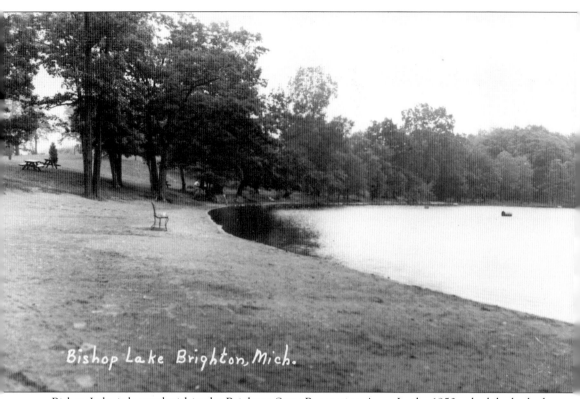

Bishop Lake Brighton, Mich.

Bishop Lake is located within the Brighton State Recreation Area. In the 1950s, the lake looked much as it does today, except the grassy area is now filled with sand and sidewalks to accommodate the number of visitors each summer.

Eight

ENTERTAINMENT
AND RECREATION

Throughout time, people have entertained themselves with singing, dancing, reading, music, plays, dining, and unforgettable stories passed down through the generations. Early Brighton settlers entertained themselves by gathering together in homes, churches, and opera houses. The residents enjoyed euchre parties (a card game) sometimes held at the Hyne home, as well as cards, checkers, and croquet. But as people evolved, so did technology, and the need for more sophisticated forms of entertainment emerged.

The majority of Michigan residents supported emancipation; in 1881, they were given the opportunity to hear a lecture from 17 emancipated slaves who were touring the country. Brighton has welcomed many new forms of entertainment over the years. Roller-skating was introduced in 1887, and by 1919, the Rialto Theatre was built for silent films. Brighton was introduced to bowling in 1902. Brighton residents loved their bands and built a new bandstand on the Millpond in 1908, so the Brighton Concert Band could perform once a week. Brighton has changed with the times, but the love for entertainment remains.

This c. 1910 postcard was sent from Brighton visitors to friends and family, wishing them well. These kinds of postcards were popular at that time. The photograph was taken in one generic location, then personalized to represent specific areas all over the country.

Well, here I am at

BRIGHTON

Only time to drop a line or two
To tell you that I am enjoying myself
And hope that you are too
Be sure to send an answer
And tell me all that's new

A town concert band was formed with instruments purchased with money donated by citizens. Its first performance was July 4, 1875. By the early 1920s, there were 15 bandsmen with the last name Seger. Here they are in 1916.

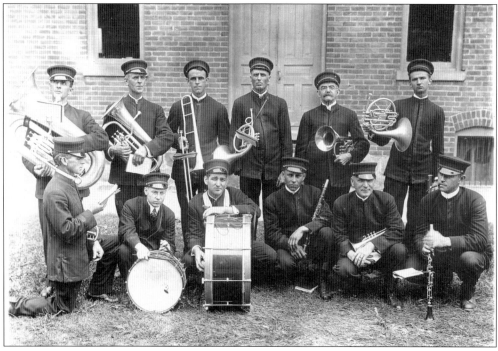

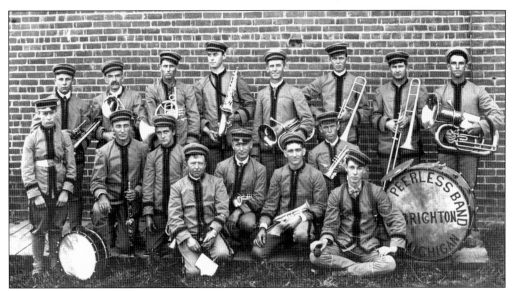

The Brighton Peerless Band poses for a picture in front of town hall in 1908. From left to right are (first row) Clifford Roberts, ? Galbraith, Frank Robbins, Dr. Hill, Fred Marschner, John Thompson, Lou Segar, and Harold Hilton; (second row) ? Herbst, William Winklehaus, Ivan Sawyer, Dick Clark, Wilbur Segar, Guy Pitkin, Frank Hacker, and Jim Segar.

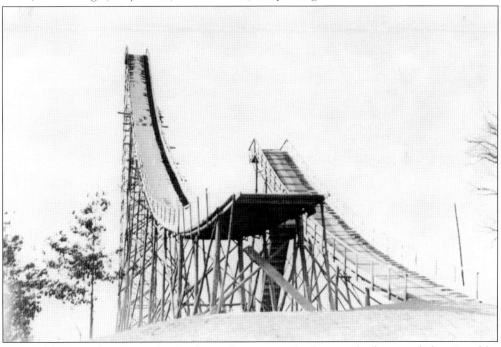

Pictured here in the 1930s, the Brighton ski jumping facility was built east of Flint Road by champion ski jumper Henry Hall. The jump was 130 feet high, but fearless skiers enjoyed soaring in the air up to 200 feet. The steps to the right of the jump enabled workers to pour snow onto the jump using buckets. When there was little or no snow, they brought it in via the railroad in box cars from Cadillac, Michigan. Brighton resident Pete Leitz remembers using the jump when he was in high school.

Before World War II, before television and before a certain ski hill popped up on Bauer Road, Brighton was a ski mecca. Back in the 1930s, people would come from far and wide to see many a brave soul soaring into the winter sky on Flint Road. Here's a look back at...

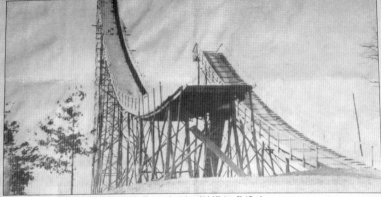

Brighton's two ski jumps, pictured sometime in the 1930s. They were located on a high hill along Flint Road.

The Brighton Ski Jump

Sixty years later, people still remember Henry Hall's big project

A couple weeks ago in his column, Buddy Moorehouse asked people to call in with information about the old ski jump that used to be in Brighton. Several longtime Brighton residents were kind enough to offer their remembrances, so here's the story.

By Buddy Moorehouse
MANAGING EDITOR

Long before Mt. Brighton became a part of the local skyline — 30 years or so before, in fact — Brighton was known far and wide as the ski capitol of Michigan.

And it was all due to the old Brighton Ski Jump.

"I remember the old ski jump quite well," said Harold "Pete" Leitz, a longtime Brighton resident who spent many an afternoon there.

They held ski-jumping tournaments in Brighton almost every weekend, and sometimes, they'd get as many as 3,000 people there to watch them. The crowds were huge."

It's been about 60 years since Brighton had its ski jump, but the memories of it are still fresh in a lot of local minds. In listening to their remembrances, here's what we know about Brighton's old ski jump:

• It was located on a high hill off of Flint Road, about a mile from downtown Brighton. Even today, it's one of the highest spots in the area.

• The ski jump was around in the 1930s. Most people remember it being built in the early-to-mid-1930s, and they say that it was torn down by 1940 or so.

• As you see in the photo, there were actually two ski jumps at the site. The larger one was a tradi-

"My brother used to put snow on the jump. He'd climb right up the scaffolds and dump it on there."

— Longtime Brighton resident Loren Nauss

tional jump (the kind you see in the Olympics), and the smaller one went directly into the hill

• The jumps were built by a man named Henry Hall, who was one of the world's best ski jumpers in the 1930s. Hall was a Ford Motor Co. employee and a devout Seventh Day Adventist. And because that religion doesn't believe in working on Saturdays, Hall's ski jump was closed down

on that day; most of the big meets took place on Sundays.

• If there wasn't enough natural snow on the jump, area kids would be hired to haul snow from other parts of Brighton and move it there. "My brother used to put snow on the jump," said Loren Nauss, who lived right near the jump. "He'd climb right up the scaffolds and dump it on there."

And back in the ski jump's hey-

day, anyone who was brave enough to strap on skis was allowed to try it.

"I went down it as a kid," Pete Leitz said. "It was pretty scary."

And if you didn't have any skis, well.

"We took a toboggan up there once," said John Stephens. "I'm telling you, it was pretty steep. It was a death-defying thing to go down that hill."

Harold Jarvis remembers jumping off the small jump. "It went right into the hill, but it was still pretty steep," he said.

Nobody, though, was a better jumper in those days than the man who built the structures — Henry Hall.

"He was a world's champion at one time," Leitz said. "I believe he held the hill record, which was about 200 feet. He also got some Olympic champions to jump there."

But never on Saturday.

"Henry Hall was such a devout Seventh Day Adventist that he never had meets on Saturday," Jarvis said. "It's funny — it's the biggest day of the week, but there was never any ski jumping on that day."

Most people remember that Henry Hall retired to the Farmington area, where he built a smaller ski jump on his property. He died some years back.

As did the Brighton ski jump. Nobody remembers exactly when it was torn down — estimates range from 1938 to 1942 — but by the time World War II got going, it was pretty much in the history books.

"There's a house up there now, where the jump used to be," John Stephens said. "And they've got a tremendous view. It's just a beautiful location."

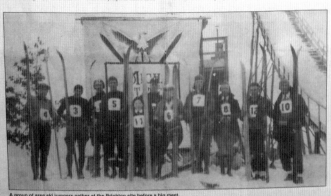

A group of area ski jumpers gather at the Brighton site before a big meet.

In the late 1930s, Henry was laid up in Mellus Hospital on Grand River Avenue after a skiing accident left him with a broken left hip, fractured rib, shattered chest bone, and slight brain concussion when he somersaulted on his landing from a 200-foot leap off the ski jump. The ski jump's demise came soon after Henry's injury. A newspaper article from the *Brighton Argus* remembers the Brighton ski jump 60 years later.

104

In this 1930s photograph, Henry Christian Hall, lower right in the first row, is the eldest of the six Hall brothers. Hall, a former Ford Motor Company employee and professional skier, set up several ski jumps in Michigan. In 2006, he was inducted into the Colorado Ski and Snowboard Hall of Fame.

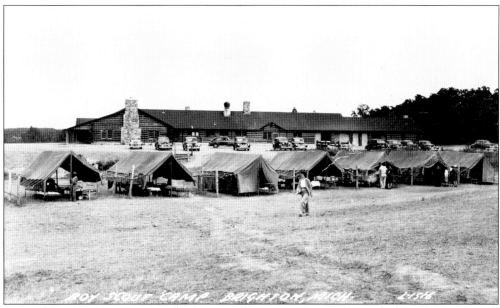

Pictured here in the 1950s, the Charles Howell Boy Scout Camp, located where the Pine Creek Ridge subdivision is today, reached to the corner of Brighton and Bauer Roads. The camp was west of the current high school, which was built in 1966. The main lodge in the background had a mess hall and some sleeping quarters. The temporary tents in the foreground offered little shelter in a storm, but they were very popular among young boys longing to be a part of nature.

Dancing was popular with young people at Brighton's Huron River Inn in the early 1950s. Located southeast of the Pleasant Valley Road–Grand River Avenue area, the inn was just one of the many venues Brighton offered to locals as well as visitors from larger cities such as Detroit.

This is a 1933 discount ticket to see Lew Caskey at the Blue Lantern Pavilion at Island Lake. Popular orchestras such as Lew Caskey drew in large crowds from all over, making the Blue Lantern Pavilion the place to be.

== NOW PLAYING ==

The Most Sensational Dance Band In This Part of the Country

"LEW CASKEY"

AND HIS FAMOUS ORCHESTRA

Blue Lantern Ballroom - Island Lake

DANCING NIGHTLY EXCEPT MONDAY

NOTE: This Ticket and 25c admits One Person any Tues., Wed. or Thur.

Void after Aug. 3, 1933 Regular Prices: Gents 40c, Ladies 35c

This is an early-1950s brochure for the Pleasant Valley Guest Ranch on Butcher Road, now part of Island Lake State Park. The ranch was open from March 15 through December 1. Built on 7,000 acres, it offered an extensive amount of recreational activities. Note the four-digit phone numbers.

A VACATION THAT IS DIFFERENT

A WEEK or A WEEKEND

PLEASANT VALLEY GUEST RANCH

7,000 acres of Scenic Recreation Land!!

7240 Butcher Road Brighton, Michigan

'Phone - Brighton 6070 or 9901

Winter storms in Michigan can deliver up to 20 inches or more of snow. Around 1943, Bill and Bonnie Armstrong play in a huge pile at their house on the northeast corner of Buno and Pleasant Valley Roads. Bonnie married Bernie Corrigan, owner of Corrigan Oil Company, in Brighton.

Brighton residents are enjoying the 1967 Centennial Parade on Main Street. The country store and ice cream parlor (near the center of the photograph) is now the Brighton Bar and Grill at 400 West Main Street.

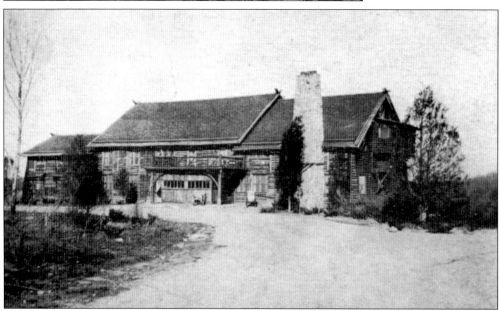

Pictured here in the 1940s, the Woodlands Golf and Country Club was located on Grand River Avenue, which used to wind around a large hill located in front of Champion Automotive. Later, the hill was removed, and Grand River Avenue was rerouted. The former route was comprised of Hacker and Bendix Roads.

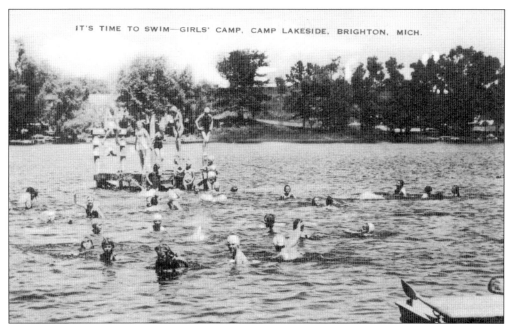

IT'S TIME TO SWIM—GIRLS' CAMP, CAMP LAKESIDE, BRIGHTON, MICH.

This 1950s photograph shows Camp Lakeside for girls on School Lake east of Old US 23 and north of Skeman Road. This camp was segregated by gender, and was run by the church that owned some property around the lake. Many social and physical activities were offered.

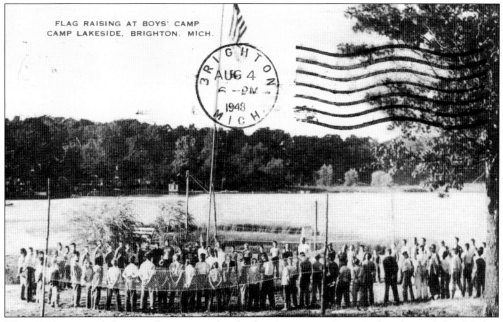

FLAG RAISING AT BOYS' CAMP
CAMP LAKESIDE, BRIGHTON, MICH.

This 1948 postcard shows a flag-raising for the boys' camp at Camp Lakeside on School Lake. Similar to the girls' camp, the boys' camp was also a religious retreat, and it had many buildings on the lake, including sleeping cabins and a dining hall.

A Boy Scout sign is visible near Brighton Lake in the 1940s. The sign uses an except from Joyce Kilmer's poem "Trees" to teach the importance of saving trees and the wilderness. This group was run by the Charles Howell Boy Scouts of Detroit. This camp was responsible for installing the dam on Ore Creek, forming Brighton Lake. Today, Pine Creek Ridge subdivision lies on the south and west sides of the lake.

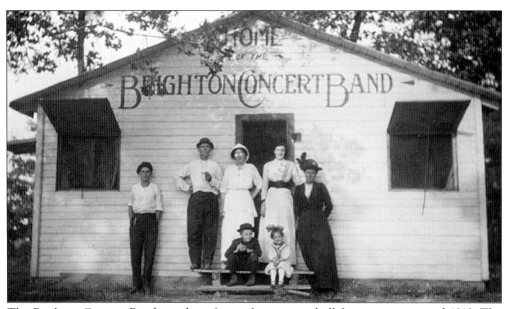

The Brighton Concert Band stands in front of its cottage hall for a picture around 1910. The group was started by Clifford Roberts and the Goucher family and consisted of local community members who performed regularly at local functions.

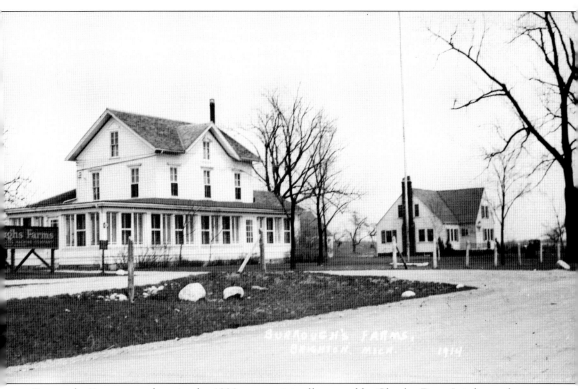

Burroughs Farms, seen here in the 1920s, was originally owned by Charles Dorr. It is located on Brighton Road east of Chilson Road on Little Crooked Lake. The Burroughs Adding Machine Company bought the property, and it provided recreational facilities for employees. The old Dorr farmhouse has been renovated into the Burroughs Tavern. It displays historic pictures of Brighton on its walls.

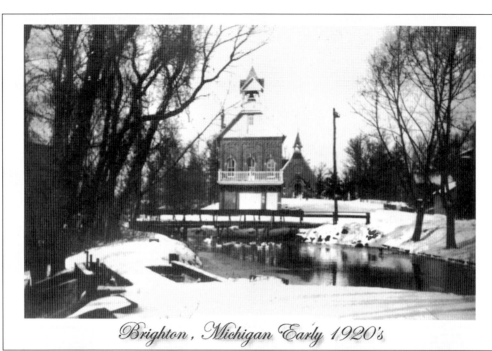

Brighton, Michigan Early 1920's

This 1920s postcard features Brighton's charming Millpond surrounded by snow. The water to the right is going to the mill, and the water to the left is going over the dam. This location is where the public parking lot is now, behind the Downtown Main Martini Bar.

"NORDICA" Cottage on Little Crooked Lake

About 1897 Laughlin and Henderson, who operated a thriving store at Chilson in a large double structure, bought the north island and built a cottage on it, probably one of the earliest lake cottages (or "camps" as they were then called) to be built in this county. It was sold in 1903 to Carl Weinmeister a blacksmith of Howell, who acquired it along with all the farm land at the south end of the lake. It was a frame structure, barn like, with few windows and no interior finish and with hand forged bolts and bars designed to frustrate attempts by any vandals to break into it. On the shingle roof was painted in large letters the name "NORDICA", named for Lillian Nordica, who was at the peak of her fame as a singer at that time. For many years this was rented to parties of young people from Howell, Brighton, Fowlerville and other nearby towns, who came in horsedrawn vehicles and spent a week or so of "camping" as it was called, duly chaperoned, of course, by their elders.

The Ann Arbor Railroad maintained a station at Chilson, which was a thriving business center, so Toledo and Ann Arbor people found the lake a convenient and delightful place for an outing during the hot weather and many families from these cities rented the "NORDICA" cottage. Mr. Weinmeister sold the cottage in 1914 to Mr. Sicar, the station agent at Chilson, and he soon sold it to one of the Toledo families, the Bauers that had been renting it. Mr Bauer later transformed the old frame NORDICA cottage into the present fine field stone summer home equipped with all the modern facilities.

Article from Livingston County Press, November 24, 1948

This 1948 article from the *Livingston County Press* is on the history behind the Nordica Cottage. The cottage was built on Little Crooked Lake, in the vicinity of Vic and Bob's Party Store at 4986 Chilson Road. This popular cottage was rented out to local people from nearby cities to enjoy camping and other activities.

Nine

PUBLIC SERVICE

It was not until after World War II that Brighton received full-time police protection. An early version of "911" is described in the city clerk's notice in the September 9, 1931, issue of the *Brighton Argus:* "A short time ago a number of houses in town were pilfered by burglars. We now have a night watchman in town who can be reached any time during the night by calling Central. In case of future trouble of this kind it is suggested that you immediately call Central, who will get in touch with our night policeman at once." Burton Miller was the town policeman for over 20 years. Miller School, built in 1957, was named after him. The first state police post was built on the corner of highways US 16 and US 23 in 1935. A special uniformed branch was formed to patrol the highways, and it was known as the "The Flying Squadron."

Brighton's fire department was started in 1876 as an organized bucket brigade with wagons pulled by the men. A Babcock hook and ladder truck was purchased for $900. In 1882, the town made another investment in firefighting equipment and purchased what became known as the "old hand pumper" fire engine. In 1981, the Main Street station was sold, and by 1982, a new fire station was constructed on Grand River Avenue.

The Brighton Area Fire Department was formed on July 1, 1998, through a merger between the City of Brighton and the Brighton Township Fire Departments. The Brighton Area Fire Department covers 74 square miles, with a population of 46,000 residents in its response district. Over the years, equipment and water resources improved. Brighton's firefighters have always been comprised mostly of volunteers, and that act alone is selfless. And even with so much change over the years, their devotion, generosity, and dedication to the citizens of Brighton remains the same.

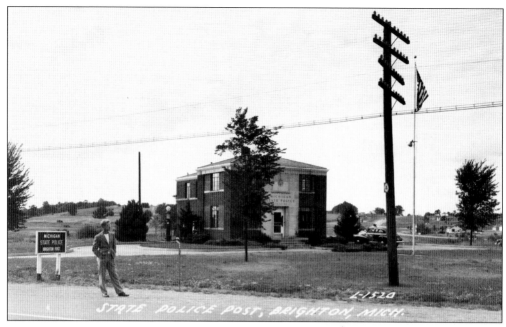

STATE POLICE POST, BRIGHTON, MICH.

The state police building, seen here in the 1950s, was built at 9995 East Grand River Avenue on the corner of US 23 in 1935. This police station was a common design throughout Michigan as the consistency kept the costs down. This location was also ideal in later years, with its proximity to I-96. The Crossroads Real Estate building occupies this site today.

The Brighton Police Department directed the 1967 Brighton Centennial Parade. Parades were one of the many fundraisers that helped support the police. Men known as "Brothers of the Brush" would grow facial hair to avoid a fine collected in support of the police department. The building in the background is the current site of the Pound restaurant.

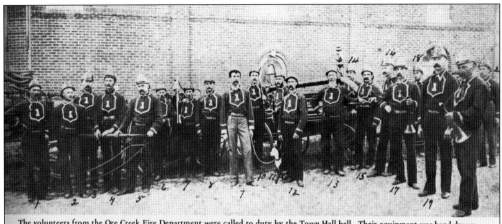

The volunteers from the Ore Creek Fire Department were called to duty by the Town Hall bell. Their equipment was hand drawn and the horn held by Mr. Winkelhouse was used to shout instructions.

1. J. Anderson 2. E. Rosencrans 3. Jean Sweet 4. Wm. Bitten 5. Geo. Pitkin 6. Felt Wehner 7. Wm. Becker 8. Ed Miller 9. Avery Prout 10. Art Boylan 11. Geo. Broadmore 12. Ansel Townsend 13. Lou Westphal 14. John Baker 15. Steve Jones 16. Chas. Campbell 17. Bill Robins 18. Le Roy King 19. Robert Parks 20. Will Winkelhouse 21. R. Roberts

The Brighton Fire Department was composed of volunteers in the 1880s. Here, firefighters pose in front of town hall, which housed the original fire hall on the first floor. Many of the volunteers were business owners in Brighton who had an obvious interest in keeping the city safe. Note no. 2, E. Rosencrans, whose number is sewn on backwards.

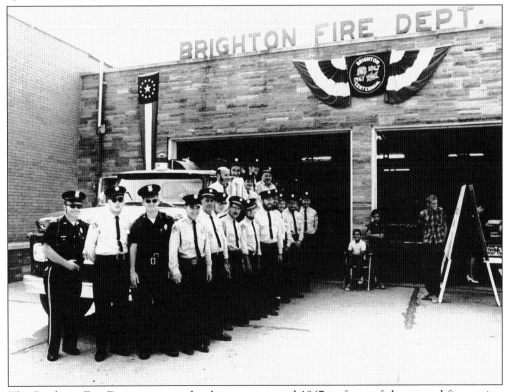

The Brighton Fire Department and police pose around 1967 in front of the second fire station at 213 West Main Street, where the Emporium is today. Harold Jarvis Jr. is the man to the left of the truck mirror; he was the fire chief from 1955 to 1969.

115

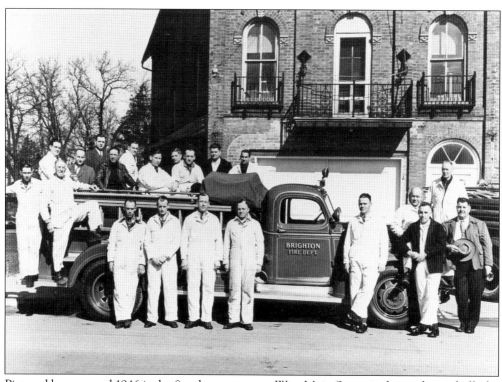

Pictured here around 1946 is the fire department on West Main Street in front of town hall, the original fire station. The white doors in the background mark where the fire truck is stored. Lee Bidwell is behind the truck in the shiny black jacket. Harold Jarvis Sr. is standing on the left of the passenger door; he was the fire chief at the time.

You are cordially invited to attend a~~~

HOP

Given by the
Brighton Fire Department

—AT THE—

OPERA HOUSE,

—ON—

FRIDAY EVENING, FEB. 8, 1901.

Music by J. B. Tinham's Orchestra.

Bill 50 cents, Supper extra in McHench Building.

BY ORDER OF COMMITTEE.

Around 1901, the Brighton Fire Department held one of its many fundraisers at the opera house at 125 East Grand River Avenue, where Stout Irish Pub is today. This fundraiser was for the annual Valentine's Day dance, in which firefighters treated their wives to a night out while collecting community funds.

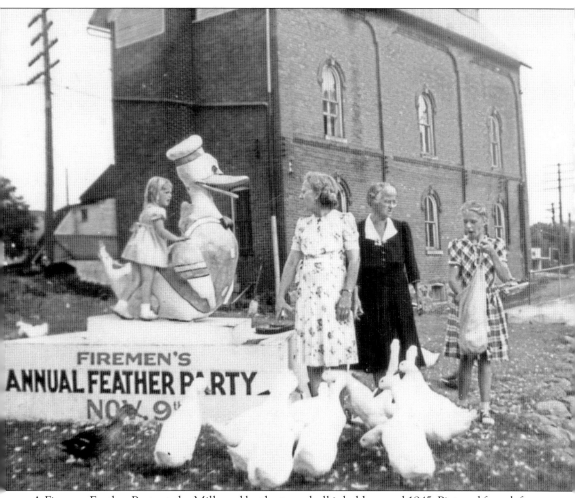

A Firemen Feather Party at the Millpond by the town hall is held around 1945. Pictured from left to right, Therese Daherr, Lizzie Pentlin, and Lucile Daherr collect feathers. The girl to the left (by the duck) is unidentified. Over the years, the Brighton fire department has supported and helped the local residents in so many ways. Each year, firefighters would stock the Millpond with ducks in the spring, and, in the fall, the ducks were fed to needy families at Thanksgiving.

Brighton Fire Chiefs

LaRue Pitkin (1898–1899)
P.G. Hartman (1911–1914)
Lawrence Navarre (1926–1928)
Adolph Marten (1928–1931)
Lloyd Pearsall (1931–1932)
Harold Jarvis Sr. (1936)
Ervin Hyne (1937)
Fred Hyne (1938–1939)
Harold Jarvis Sr. (1940–1954)
Harold Jarvis Jr. (1955–1969)
John Dymond (1970–1971)
Mel Sanch (1972–1985)
Gary Danforth (1986–1988)
Richard Shinske (1989–1994)
Larry Lane (1995–2005),
Martin DeLoach (2005–2009)
Larry Lane (since 2009)

Ten

WAR AND THE MILITARY

The Brighton community, like so many others, has been profoundly affected by war in many ways. The sweet victory of change and growth goes hand in hand with sadness and loss. War touches all of our lives, whether fighting at the front lines of battle, or struggling to survive back home. War leaves two things in its wake—gain and loss.

The Civil War left perhaps the largest scar on Michigan. While the war may not have been fought on the state's northern soil, the community suffered all the same. Michigan overwhelmingly voted for Lincoln, and more than 90,000 men served in the war over a four-year period—80,000 of them were volunteers. Over 260 of those men were from Brighton, Hamburg, Green Oak, and Genoa, and at least 59 died. Approximately 14,000 men from Michigan lost their lives. The South surrendered on April 9, 1865.

Pres. William McKinley called for a declaration of war, which Congress enacted on April 25, 1898 (and made retroactive to April 21), and the Spanish-America War officially began. Gov. Hazen Pingree established Camp Eaton for the soldiers at the south end of Island Lake, where they assembled and trained. Michigan contributed four regiments; three of them were sent to Cuba. Armed conflict in the brief war ended in August 1898, and the Treaty of Paris ending the war was signed that December—but the hostilities did not end without leaving a mark on Brighton and its citizens.

America entered World War I in April 1917 with Pres. Woodrow Wilson at the helm. Local support from Livingston County helped with the purchase of Liberty Bonds and other war programs. The families, farmers, and businesses of Brighton did their part for the war and their government by conserving food, electricity, and fuel. Brighton and the surrounding areas sent approximately 80 of their men into war, and 26 lost their lives. The warfare ended in November 1918, with the Treaty of Versailles signed in June 1919.

People can still recall with vivid detail where they were on December 7, 1941, when they received news of Japan's attack on Pearl Harbor. Only 23 years had passed since World War I, and America was at war again. World War II was financed by the sale of war bonds, and just as in all the prior wars, Brighton residents dutifully answered the call with their support in every way possible. By the time the Japanese surrender took place in September 1945, Brighton had lost 23 men.

If character is built in a time of pain and loss, then Brighton has become what it is today because of the sacrifices made by the soldiers, their families, and the residents.

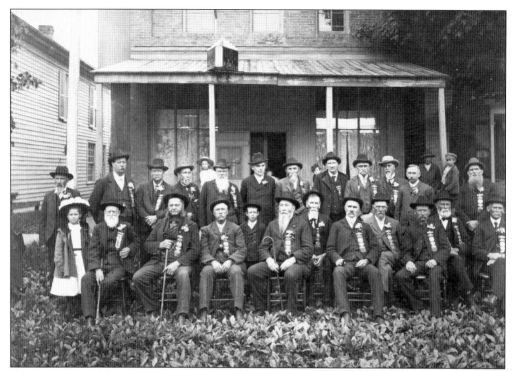

The remaining soldiers of the Grand Army of the Republic gather together for a group photograph in front of the Masonic Hall at 120 West Grand River Avenue around 1904. This building is occupied by Michigan Lending today.

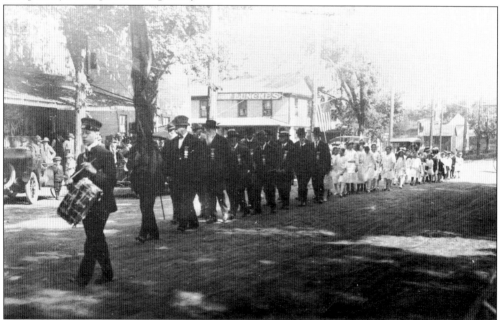

This is an early-1900s Memorial Day parade on East Grand River Avenue. Members of the Grand Army of the Republic march to Village Cemetery to pay their respects to their fellow soldiers of the Civil War. They are passing by what is today the site of Stout Irish Pub.

Here are the Spanish-American War veterans on a Memorial Day around 1920, with St. Paul's Episcopal Church in the background. From left to right are John Strick, Frank Hunter, Robert Milett, D.C. Burrett, and Al Stonex.

Pictured here around 1920 on Memorial Day are, from left to right, (first row) Ben Bidwell, Russ Shannon, Eric Singer, Louis Kourt, Burchard Bitten, Harry Wright, and Charles Duncan; (second row) William Weston, Trevor Rickett, Ralph Hamburger, George Holderness, Clyde Sweet, and Robert Hodge; (third row) Guy Smith, Dave Haywood, Gerald Case, Harold Conrad, Harry Birkenstock, and Frances Blatchford. The men are posing in front of town hall.

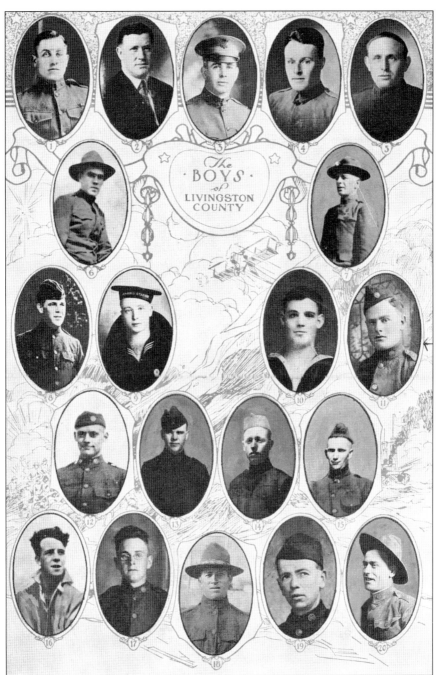

This c. 1917 composite shows the "Boys of Livingston County" who fought in World War I from 1917 to 1919. From left to right (beginning at the top left) are Earl Purcey, Gliff Knight Collett, Claud Collett, George Eric Singer, Herman Charles Hoff, Bed B. Bidwell, William J. Felt, Charles W. Palmer, Jack W. Bell, Clifford Leach, Robert W. Hodge, Peter James Leitz, Orwell B. Krieger, Henry Wilton, George Henry Holderness, William Lee Weston, Geo. L. Priestley, Frederick K. Janke, Trevor D. Rickett, and Orla Marrihew. Edwin B. Winans Jr. was a brigadier general and the son of the former governor. There is a lake and a street named after the family.

LIVINGSTON'S
ROLL OF HONOR

ABRAMS	ALLEN
AVIS	BRIMLEY
COOLEY	DEVEREAUX
GLENN	HAAS
HARDY	HENDRICKSON
HICKS	HULL
KING	LEIGHTON
McKINLEY	MACKINDER
OWENS	ROBERTS
RORABACHER	ROSE
SKUTT	TANNER
THOMPSON	TIFFANY
WASHBURN	WATSON

"To live in hearts we leave behind is not to die."

This list of Livingston County soldiers lost in World War I is from the 1920s. Local citizens of Brighton have always been very supportive of soldiers and their families. An honor roll was also displayed on the southwest corner of Main Street and Grand River Avenue for World War II soldiers.

This is a capital stock certificate issued by the Michigan Military Academy. Located on the southeast end of Island Lake, the academy was established by Tom S. Leith, a former mayor of Brighton. His signature is at the bottom right.

A touching tribute of "Taps" is played to honor the soldiers of all the wars who gave their lives for our country on Memorial Day, 1946. Brighton citizens never forget the soldiers who sacrificed so much, and continue the tradition of honoring them each year on Memorial Day at the Millpond.

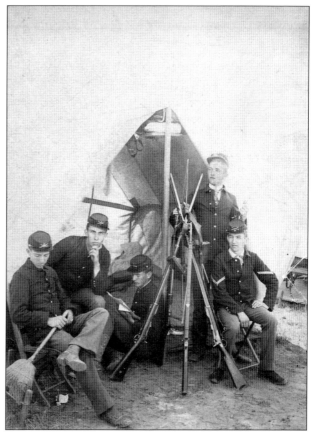

The Michigan state troops 2nd Regiment, Company D, State Encampment gather in Brighton in the 1890s. In 1893, by legislative act of the state, they became known as the Michigan National Guard. From left to right are Earl Shaffer, Charles Kaiser, Wallace Schock, James Harold, and Louis Schoch.

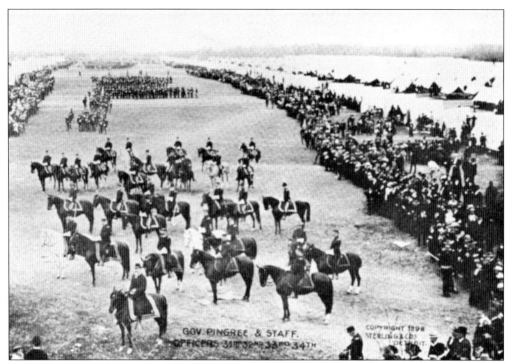

Camp Eaton, seen here around 1898, was the deployment station and training center at Island Lake for the Spanish-American War. Gov. Hazen Pingree and staff are overseeing the training and day-to-day operations of the officers and soldiers. The organized camp was lined with makeshift tents for the soldiers while they were training.

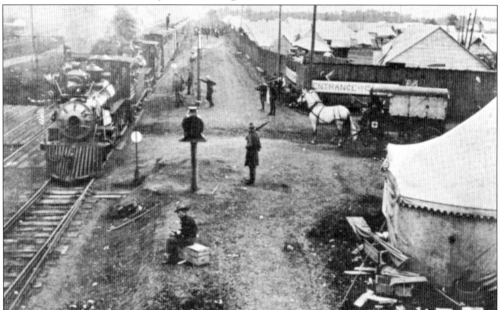

Around 1898, the 33rd Regiment is preparing to leave by train as it is deployed to carry out service for the war. Some regiments were deployed to Florida, and some were sent directly to Cuba. The horse and buggy are stopped on Academy Drive with supplies.

ABOUT THE
ORGANIZATION

A generation which ignores history has no past and no future.

—Robert A. Heinlein, *Time Enough for Love*

Many of the photographs were generously donated to the Brighton Area Historical Society (BAHS) by Marianne Comiskey. All of the author's proceeds from the sale of the book will be donated to the BAHS in an effort to continue its worthwhile cause. These photographs and hundreds more are available for purchase through the BAHS.

The BAHS is interested in obtaining more historic photographs of Brighton and its early history. Please consider sharing any historic photographs you may have with the BAHS to scan for its archives. If you would like to volunteer your time, share historic photographs, or make a monetary donation to the Brighton Area Historical Society, please contact president of the BAHS Jim Vichich at jvichich@comcast.net or visit Brightonareahistorical.com/about. The BAHS can also be reached by mail at PO Box 481, Brighton, Michigan, 48116.

Our mission is to preserve, disseminate, and advance our knowledge of the history of the Brighton Area. Carol McMacken's book *From Settlement to City: Brighton, Michigan, 1832–1945* is a complete work on the history of Brighton. McMacken's research included almost a decade of work and checking historical resources from all over the state. This book gives an in-depth account of all aspects of Brighton and the early settlers and is available through the Brighton Area Historical Society.

DISCOVER THOUSANDS OF LOCAL HISTORY BOOKS
FEATURING MILLIONS OF VINTAGE IMAGES

Arcadia Publishing, the leading local history publisher in the United States, is committed to making history accessible and meaningful through publishing books that celebrate and preserve the heritage of America's people and places.

Find more books like this at
www.arcadiapublishing.com

Search for your hometown history, your old stomping grounds, and even your favorite sports team.

Consistent with our mission to preserve history on a local level, this book was printed in South Carolina on American-made paper and manufactured entirely in the United States. Products carrying the accredited Forest Stewardship Council (FSC) label are printed on 100 percent FSC-certified paper.